Bruno Santi

BOTTICELLI

SCALA/RIVERSIDE

CONTENTS

Sandro Filipepi, Florentine Painter 3

Early Development 6

Sandro Botticelli and the Neo-Platonism
of the Medici 15

The Age of Savonarola: Pathos
and Tragedy 50

Index of the Illustrations 79

Short Bibliography 80

© Copyright 1991 by SCALA, Istituto Fotografico
Editoriale S.p.A., Antella (Florence)
New unabridged edition
Editing: Karin Stephan
Photographs: SCALA (M. Falsini and M. Sarri) except:
no. 12 (by courtesy of the Isabella Stewart Gardner
Museum, Boston); nos. 57, 58, 59, 60, 88, 89, 90 (by
courtesy of the National Gallery, London); nos. 62, 63
(by courtesy of the National Gallery of Art, Washington);
no. 68 (Gemäldegalerie, Berlin-Dahlem); no. 85 (by
courtesy of the Metropolitan Museum of Art, New York);
no. 95 (by courtesy of the Fogg Art Museum,
Cambridge/Mass.); nos. 99, 100 (Vatican Library,
Vatican)
Photo type-setting: "m & m", Florence
Colour separations: Fotolito RAF, Florence
Produced by SCALA
Printed in Italy by Centrooffset
Siena 1991

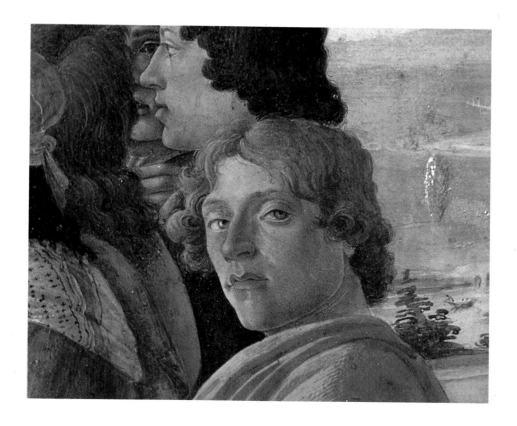

Sandro Filipepi, Florentine Painter

Alessandro, the youngest of four sons, was born in Florence to Mariano and Smeralda Filipepi who lived on Via Nuova, today's Via del Porcellana, in the quarter of Santa Maria Novella not far from the Arno river. Alessandro's father, together with many other inhabitants of the area, was a tanner, and was aided in his trade by the proximity of the Arno and the Mugnone torrent which emptied into the Arno at Prato d'Ognissanti. The first written notice of Alessandro is found in the so-called 'portate al Catasto', the declarations of income for tax purposes which every head of family was ordered to make by decree of the Republic in 1427. In one of these, in 1458, Mariano Filipepi stated that he had four sons, Giovanni, Antonio, Simone and Sandro: the latter was thirteen years old and was 'studious and sickly'. This phrase of his father's casts a light on the introspective nature of the boy, possibly due to childhood illnesses, which certainly left its mark in the melancholy tones of many of his paintings.

Around 1464 Alessandro entered the workshop of Fra Filippo Lippi where he stayed until his twenty-second year in 1467. His first work may well have been on the last frescoes painted by Fra Filippo and his students for the Cathedral in Prato.

In 1469 he was working on his own because a declaration by Mariano stated that he was working at home. The careers of the four sons (Giovanni became a pawnbroker, a position corresponding to that of a government official, and earned the nickname of 'Botticella' which was to pass on to his more famous brother) brought money and position to the family. They owned houses, land, vineyards and shops. On 9 October 1469 Fra Filippo died in Spoleto. The following year Sandro began his own workshop: here, between the 18th of June and the 18th of August of that year, he completed a work which was to bring him both public acclaim and artistic prestige. This painting was *Fortitude* (one of a series depicting the seven Virtues) commissioned for the Tribunale di Mercatanzia (a court where crimes of an economic nature were judged), one of the most important local institutions. The other Virtues had been commissioned from a well established painter, Piero del Pollaiolo, which is an indication of the prestige enjoyed by Sandro in Florentine artistic circles. In 1472 he joined the Compagnia di San Luca (the painter's guild) and also had his dear friend and collaborator, the fifteen-year-old Filippino Lippi, son of his old teacher, registered in the guild. Botticelli's commis-

sions were primarily for Florentines; the important painting of *St Sebastian* (now in Berlin) was done for the Church of Santa Maria Maggiore. However, in the year 1474 he was sent for outside of Florence. The Pisans needed his collaboration on a cycle of frescoes for the Camposanto Monumentale (Monumental Cemetery) and commissioned an altarpiece depicting the *Assumption of the Virgin* as a trial. Sandro — for unknown reasons — never finished the painting, nor did he work on the frescoes. It was during these years that the painter established his close relationship with the house of Medici, by then the recognized rulers of Florence. He painted banners for a famous tournament held in 1475 in Piazza Santa Croce in honor of the brother of Lorenzo the Magnificent, Giuliano. Giuliano was killed in 1478 as a result of a conspiracy conceived by Pope Sixtus IV and carried out by members of the Pazzi family against the Medici. Sandro painted effigies of the conspirators, both those who had been executed and those still at large, on the facade of Palazzo della Signoria by the side of the Porta di Dogana (Customs Gate). With this gesture Sandro embraced the cause of the house of Medici and the period of his greatest prestige and most intense activity began. By 1480 his workshop was large and well-known to judge by the number of students and assistants registered in the 'Catasto'. In the same year he painted the *St Augustine* for the Church of Ognissanti for the Vespucci family, one of the most important families of the city who were closely allied with the Medici.

The new cultural policy of Lorenzo the Magnificent, who sought a reconciliation with the Pope, led to Botticelli's departure for Rome (27 October 1480) together with Cosimo Rosselli, Domenico Ghirlandaio and Pietro Perugino, to fresco the walls of the Sistine Chapel. He left Rome towards the end of February 1482. The contract for the frescoes was settled on the 17th of the month and on the 20th his father died in Florence. The return to Florence was final and the Signoria gave him, together with the most qualified painters of the day, Ghirlandaio, Perugino, and Piero del Pollaiolo, the commission to fresco the Sala dei Gigli (Room of the Lilies) in the Palazzo dei Priori (now called Palazzo Vecchio) on 5 October 1482. Sandro, however, did not execute this work. The following year, with the assistance of his students, he painted for Lorenzo the Magnificent four panels of a chest with the story of Nastagio degli Onesti, a tale from Boccaccio's *Decameron*. 1487 saw Sandro at work on yet another civic commission: the Magistratura dei Massai di Camera (tax officials) ordered a *tondo* for their audience hall in the Palazzo della Signoria. This work is known today as the *Madonna of the Pomegranate*. The arrival of Savonarola on the Florentine political scene did not go unobserved by Botticelli; as we shall see, religious themes began to predominate in all his paintings. The years 1489-90 saw the completion of an *Annunciation* painted for the Cistercian monks (today at the Uffizi), while the restlessness of his nature led him to be fined for an unknown infraction of the law by the Ufficiali di Notte e Monasteri (a disciplinary commission). Meanwhile, commissions poured in. With Gherardo and Monte di Giovanni, famous mosaic artists, he was asked to create a mosaic decoration of two ceilings in the Chapel of St Zenobius in the Cathedral of Florence. He was also asked, together with Lorenzo di Credi, Ghirlandaio, Perugino and Alesso Baldovinetti, to form a committee with the purpose of deciding upon a facade for the Cathedral. Three years later Sandro's brother Giovanni died. In 1495 he carried out his last work for the Medici, painting for that branch of the family later known as 'the Medici of the people' several works for their villa at Trebbio.

In 1498, the year of the execution of Savonarola, his income declared in the 'Catasto' was considerable; he had a house in the Santa Maria Novella quarter and collected rent from a villa in Bellosguardo, outside the Porta San Frediano. But Botticelli was deeply disturbed by the Dominican's death. In Simone Filipepi's *Cronaca* (1499) there is a record of a conversation between Sandro and Doffo Spini, who was one of the judges at the trial that condemned Savonarola to death; Sandro's words voice his feelings of what to him seemed a grave injustice. The influence of the Dominican made a deep impression on Sandro, whose work became more visionary and more isolated from the general stream of Florentine artistic trends in those early years of the new century. In the year 1501 he painted the *Mystic Nativity* with its apocalyptic symbols and allusions to the present situation in Italy, and for the first time he signed and dated a painting. Although he was aging, his opinion still carried considerable weight and was sought after by his contemporaries. In 1504 he was part of a committee, along with Cosimo Rosselli, Giuliano da Sangallo, Leonardo da Vinci and Filippino Lippi, formed to decide where to place the newly executed *David* by Michelangelo. The opinion of Filippino Lippi prevailed and the marble 'giant' was

2. *Madonna in Glory with Seraphim*
120 x 65 cm
Florence, Uffizi

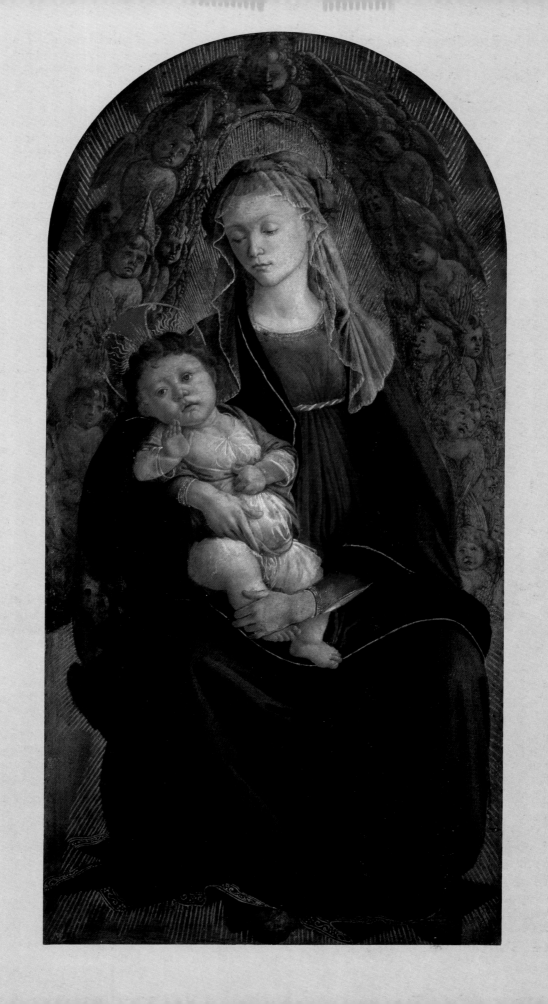

placed on the platform outside the Palazzo della Signoria.

The old painter, by now practically inactive and nearly forgotten in a Florence that had surrendered her leadership in the field of the figurative arts to Rome, died on 17 May 1510 and was buried in the family tomb in the church of Ognissanti.

3. Filippo Lippi
Madonna and Child with Angels
Florence, Uffizi

4. *Madonna of the Rosegarden*
124 x 65 cm
Florence, Uffizi

Early Development

Critics have found three basic trends in Botticelli's artistic development. These are evident from the very first works of the painter around the year 1470, that is as soon as he had finished his apprenticeship in the workshop of Fra Filippo Lippi. Lippi died in Spoleto in 1469 while engaged in frescoing the Cathedral.

The earliest influence on the young Botticelli was certainly Lippi, an influence seen most strongly in the facial characteristics of Sandro's figures, a style he continued even in the later works. The earliest Botticelli paintings are seen by critics as variations of the famous Lippi *Madonna and Child with Angels* of the Uffizi. The themes of the first Florentine Renaissance were still visible in the works of the Carmelite Lippi, who transformed the solid volume of Masaccio's work into relaxed and imaginative forms and changed the severe heroism of the figures of this first great Renaissance master into a colorful and lively down-to-earth representation. However, the artists of the third generation of the Renaissance — above all the Pollaiolo brothers, Piero and Antonio, as well as Andrea del Verrocchio — brought to perfection a new stylistic tendency, each according to his own temperament, transforming yet again the style of Masaccio that had already been changed in linearity and use of color by the greatest artists of the second generation of the Renaissance, that is by Lippi himself and Andrea del Castagno.

It is in the painting of Antonio del Pollaiolo and Andrea del Verrocchio that the other two currents in the style of Botticelli are to be found. The dynamic line and energy of the former, who was able to create figures with only the design of a profile and who changed completely the depiction of movement, was one influence; the capacity of the latter to elaborate on living forms and place them

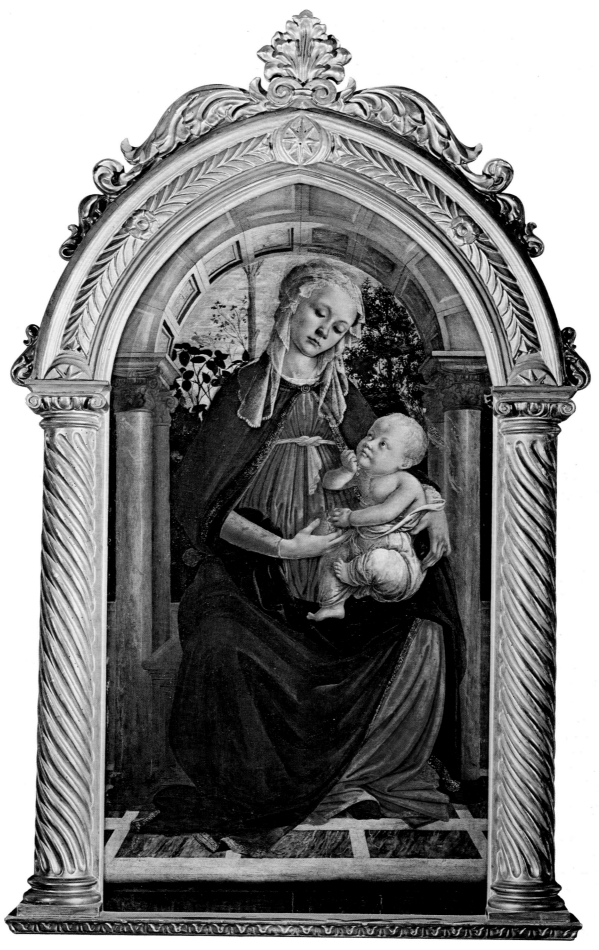

5. *Piero Pollaiolo*
Temperance
Florence, Uffizi

6. *Antonio Pollaiolo*
Hercules and Antaeus
Florence, Uffizi

7. *Andrea Verrocchio*
Doubting Thomas
Florence, Church of Orsanmichele

8. *Fortitude*
167 x 87 cm
Florence, Uffizi

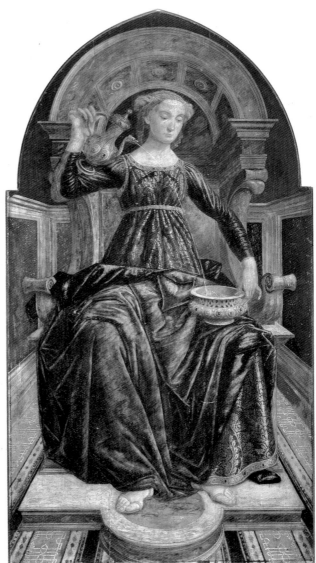

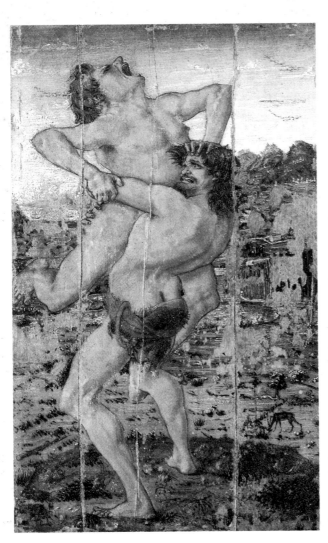

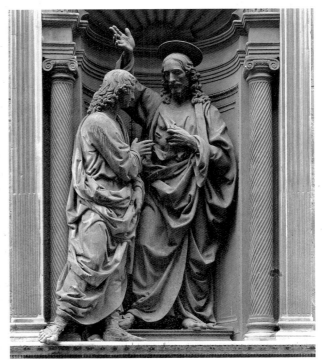

in their proper setting, shading the forms with light and color so as to put in play the tactile qualities of the subject (a direction in which the young Leonardo was moving), was the other.

The Botticellian style evolved from these three directions. Naturally — as with all great painters — Sandro's style was not a simple mechanical synthesis of the style of his masters, but an original and unique personal expression. Sandro, with his sensitivity, was able to take what he had learned from his teachers and add to it certain elements of his own: for example, the faces in his paintings with their slightly melancholy expression, characteristic of withdrawn and thoughtful natures. Also, his primary interest was in the human figure, not in the setting (a reason for considering him a precursor of the Mannerists even though the cultural foundations were quite different); and a linearity sometimes used to denote expression (forms that are modified depending on the sentiment to be expressed). These tendencies are particularly evident in his later work. Unlike many other artists, Sandro retained these elements, without any major change, throughout his entire artistic career. What did change was the subject matter and also every time the linear component, the color and the expressionistic elements were more accentuated. In some of the later paintings the colors are very pure, clear and nearly blinding in their intensity, as though the lessons of Verrocchio had been quite forgotten.

From his very earliest works he expressed clearly these stylistic qualities. In the tradition of Lippi, particularly in the faces, are the two Madonnas in the Uffizi: the one called *Madonna of the Rosegarden*, the other with its 'glory' of seraphim. Both are stylistically very recognizable, especially in the figure of the Virgin which is more elongated and articulated than in Lippi's paintings. The Child of the *Rosegarden* is in the style of Verrocchio, while the other Child is especially Botticellian, so aware is he of his sacred nature, and has a wistful melancholy expression. Sandro's most prestigious work of the 1470s, however, is the *Fortitude* of the Uffizi commissioned by Tommaso Soderini in May 1470 for the Tribunale della Mercatanzia. The painting was paid for on 18 August 1470. The entire series of Virtues had been ordered from Piero del Pollaiolo in 1469; Pollaiolo protested when he learned that Botticelli had been asked to do a second Virtue, a decision which led to a protest by other painters and the withdrawal of the commission to Botticelli. The figure of *Fortitude* is placed on a high throne with elaborately carved arms, a piece clearly traceable to Verrocchio, but the feeling of tension that this thoughtful figure gives off

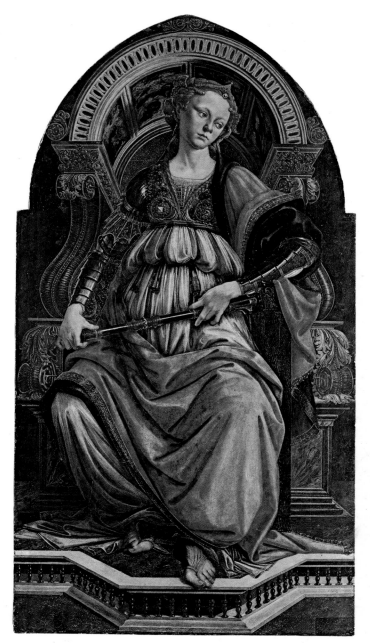

surely comes from Antonio del Pollaiolo. The blue enamel work on the armour and the highlights on the metal are particularly interesting as they indicate a thorough knowledge of the goldsmith's art. The way in which cloth is portrayed comes from Verrocchio (see, for example, the heavy drapery in the *Doubting Thomas* at Orsanmichele). The energy and vitality of the girl in armour, expressed in her face and her pose, is an original creation of Botticelli's and shows clearly the very personal way in which he developed and enriched the styles of his contemporaries.

The *Madonna* at the Isabella Stewart Gardner Museum in Boston was the end product, showing the synthesis of trends that formed the style of Botticelli's painting. The composition of the painting resembles Lippi's art, but the figures are more deli-

cately blended into the painting and their expressions and poses are more complicated. The figure of the Christ Child reaches from his mother's lap to bless the bunch of grapes and stalks of grain held out to him by the angel, symbolizing the sacrament of the Eucharist (the bread and wine that become the body and blood of Christ), in a more explicit manner than the traditional one of the pomegranate used by the Florentine painters of the early fifteenth century.

From Lippi, and through him from the iconography of Verrocchio, comes the composition of the landscape framed in the tall, open piece of furniture that forms the background of the scene. Botticelli then attempted to illustrate an episode from the Bible, painting two pictures of the Stories of Judith, believed by critics to be painted primarily in 1472. Though tiny in size, they are masterpieces because of the complexity of the composition, the attention to minute details and the atmosphere in each scene. Especially noteworthy is the atmosphere of tragedy in the *Discovery of the Body of Holofernes*, where the body of the Assyrian warrior-king — a nude created with the dynamic linearity of Pollaiolo — sprawls headless on his couch, surrounded by officers in various poses and with expressions showing despair, horror and shock. Even the material of the tent and the curtains, coarse and heavy, add to the overall impression of gloom, in spite of the reflections of light on the armour and the lavish harnesses of the horses. The atmosphere of *Judith's Return to Bethulia* on the other hand is free and serene; the colors themselves are lighter, the cloth is no longer coarse but

decorated with lace, and the landscape, animated with brilliant figures, is filled with the light of dawn. The two main figures, the Hebrew heroine and the lady-in-waiting, with their clothes blown by the wind, walk so lightly that they seem weightless. The iconography is classical and was also used by Donatello on the base of the statue of *St George*, originally placed in Orsanmichele, as well as in the 1452 *Bartolini Tondo* by Lippi.

Sandro then began painting portraits in the fifteenth-century Florentine tradition, but to the official, flattering portraits then in fashion he added a subtle psychological tension. In the *Portrait of a Man with the Medal of Cosimo the Elder*, a work that was an indication of the ties that were to bind Sandro to the Medici family, the man has never been definitely identified, notwithstanding the many suggestions made by scholars. The most plausible suggestion is that the man is Sandro's brother, Antonio (there is a marked family resemblance to Sandro's self-portrait in the *Adoration of the Magi* in the Uffizi), who according to certain documents was often commissioned to cast medals for the city's ruling family. The expression is intense, the features softened by an attempt at portraying classical beauty; the hands are agile and nervous as they hold the medal with pride. In the background is a vast landscape showing the winding course of the Arno, in keeping with the Florentine tradition of the period.

By 1470 Botticelli's style was completely formed. His work was enriched in the following years by the Humanistic themes found in the commissions given to him by members of the Medici family.

9. Portrait of a Young Man
51 x 33.7 cm
Florence, Galleria Palatina (Palazzo Pitti)

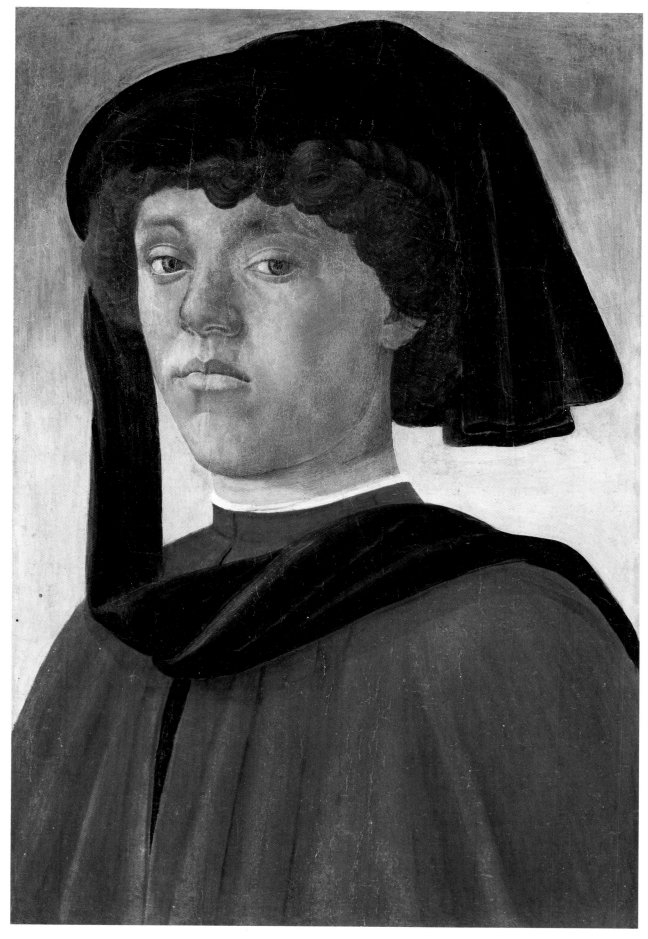

11

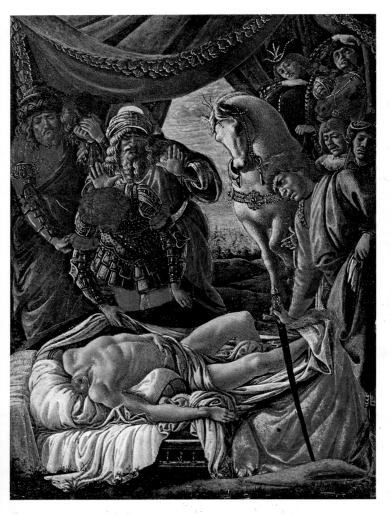

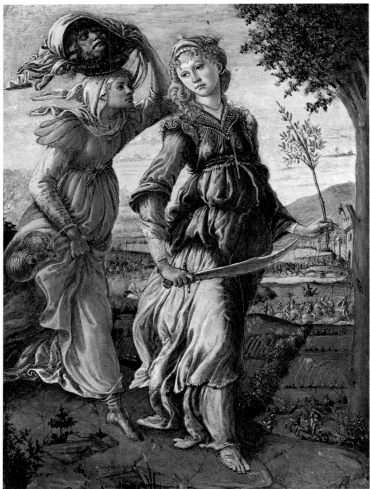

10. *Discovery of the Body of Holofernes*
31 x 25 cm
Florence, Uffizi

11. *Judith's Return to Bethulia*
31 x 25 cm
Florence, Uffizi

12. *Madonna and Child with an Angel*
85 x 64.5 cm
Boston, Isabella Stewart Gardner Museum

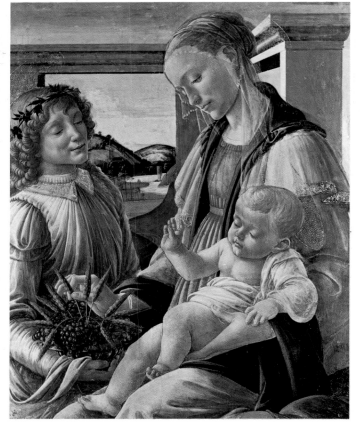

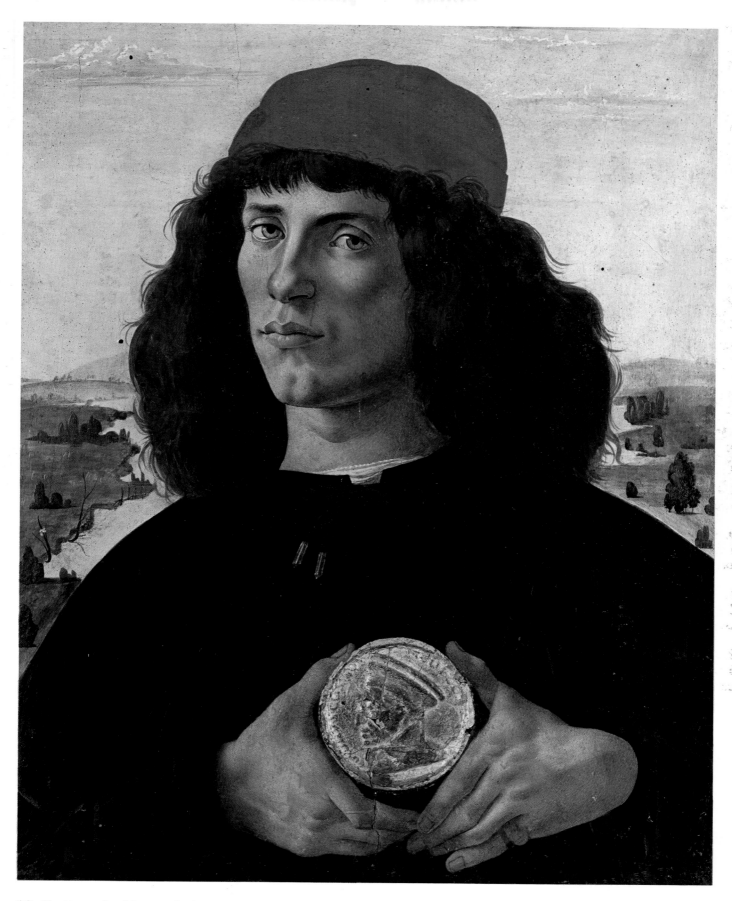

13. Portrait of a Man with the Medal of Cosimo the Elder
57.5 x 44 cm
Florence, Uffizi

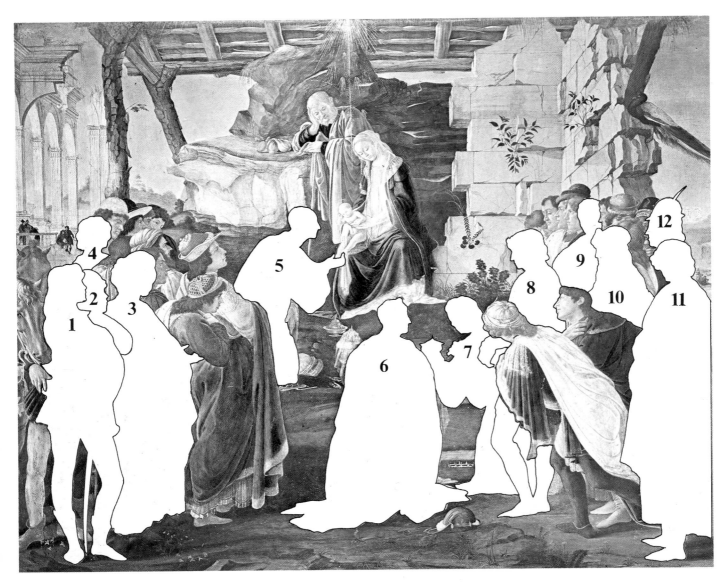

14. *Scheme of the Adoration of the Magi. From left to right:* 1) *Lorenzo the Magnificent;* 2) *Agnolo Poliziano;* 3) *Giovanni Pico della Mirandola;* 4) *Gaspare Lami, who commissioned the work;* 5) *Cosimo the Elder;* 6) *Piero 'the Gouty';* 7) *Giovanni de' Medici;* 8) *Giuliano de' Medici;* 9) *Filippo Strozzi;* 10) *Joannis Argiropulos;* 11) *Sandro Botticelli;* 12) *Lorenzo Tornabuoni.*

15. *Adoration of the Magi*
111 x 134 cm
Florence, Uffizi

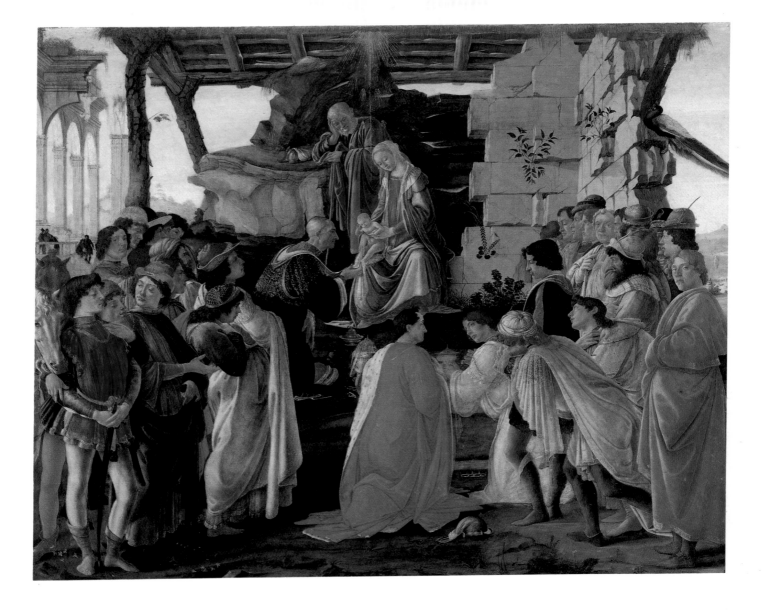

Sandro Botticelli and the Neo-Platonism of the Medici

Sandro's most important paintings, the master-
pieces that have won him acclaim not only from
critics but from the entire museum-going public,
were created almost completely within the sphere
of the Medici family and reflect the cultural at-
mosphere which surrounded it. It seems appropri-
ate to sketch briefly here the history of the family
and of its most influential members. The founder of
the family's fortunes was Cosimo, the son of
Giovanni (called Cosimo the Elder by later histori-
ans to avoid confusion with Cosimo, the first
Grand Duke) who in the third decade of the
fifteenth century opposed the ruling regime led by
his rivals, the Albizzi family. He was imprisoned in
Palazzo della Signoria (now called Palazzo Vec-

chio) and then exiled in 1433. A year later he
returned in triumph and with the full authority to
put into practice his political plans for the city and
make himself and his family the city's rulers. He
used his vast fortune to these ends.

The great epoch of Medici patronage began with
Cosimo the Elder. First there were buildings by the
greatest architects of the period, Brunelleschi and
Michelozzo di Bartolommeo. Then followed other
cultural as well as ecclesiastical innovations. An ex-
ample of the latter was the Council of Florence,
which gathered together all the Bishops who had
previously met in Ferrara and were attracted to
Florence by Cosimo's generosity and his prestige
(in 1439 he was made Gonfalonier, or Chancellor

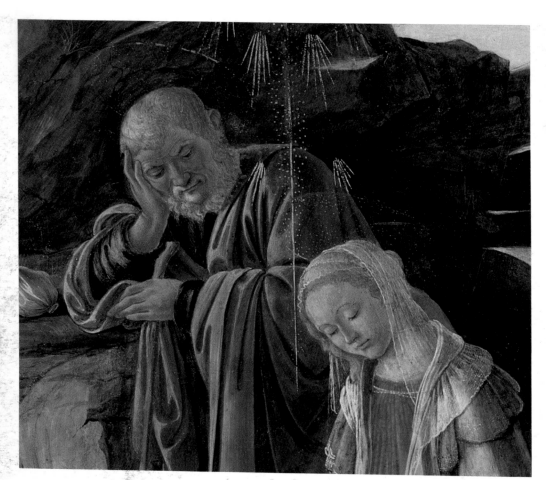

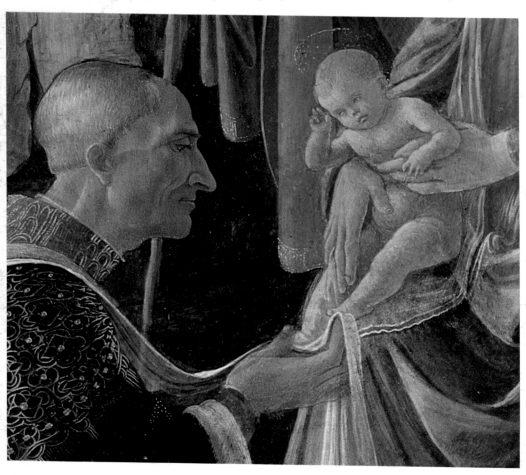

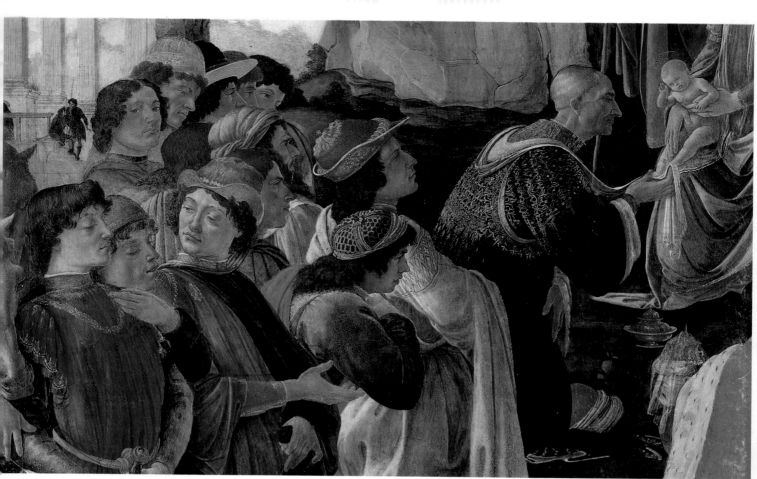

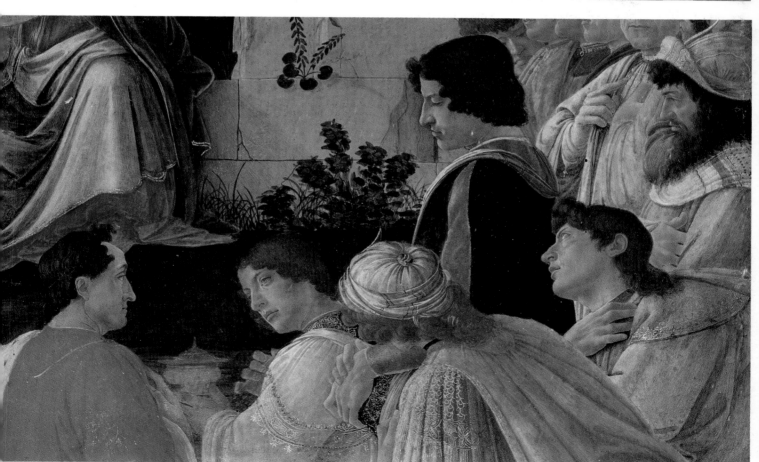

of the city). Cosimo also established the Platonic Academy, which met in his villa at Careggi. The villa was restored by Cosimo and it was here that he died in 1464. The ends to which all Cosimo's efforts were directed were the strengthening of ties between the various members of his family, enhancing the family's prestige, and assuring its position of supremacy in the state. He had a plan in which, without widespread revolution or even disturbances, the government of the city would become a real Signoria (a government by one lord), at the same time preserving some of the republican institutions and placing trusted followers in charge of them.

When Cosimo died his plans had not been accomplished; although the family was rich and powerful, it was not numerous. The programs that Cosimo had outlined seemed far too ambitious for such a small family to carry out; his pronouncements from the palace in Via Larga seemed voiced with regret that no large group of heirs was available to continue his work. However, the family's fortunes and prestige prospered after its founder's death. Cosimo's son Piero (called 'the Gouty') was able to keep the power left to him by his father during his brief reign (1464-1469) and, despite his ill health, he carefully prepared for the succession of his sons, Lorenzo and Giuliano, using his personal authority to see that his heirs would be accepted as the city's rulers. In 1471, in fact, the most important men of the city asked Lorenzo to become ruler of the city, following in the footsteps of his father and grandfather; thus the dynastic succession was assured. Lorenzo used his powers with a great sense of duty, differing from Cosimo in that he put the interests of the state before those of his family. However, he did see to it that his son Giovanni was made a cardinal (Giovanni later became Pope Leo X). His policy of inviting (and paying for) artists and literary figures to come to Tuscany led to a wider cultural exchange and collaboration. The Pazzi conspiracy of 1478 (master-minded by Pope Sixtus IV, who looked with disfavor upon the rise of the house of Medici), although it cost the life of Giuliano, showed the consensus of the Florentine people in favor of the Medici. It was the population who fell upon the conspirators and executed them summarily. From 1478 until his death in 1492, Lorenzo was personally involved in political matters — uniting Italian princes in peace treaties that would keep foreign powers, notably France and Spain, from invading Italy — and artistic and cultural affairs. He surrounded himself with such important figures as Marsilio Ficino, Agnolo Poliziano, Pico della Mirandola, philosophers, poets and men of letters. The age of Humanism had begun:

the artists and intellectuals of the early fifteenth century were fascinated by the rediscovery of Greece and Rome. Florence had become the principal artistic center of Italy, not only in terms of quality, but also in terms of the large number of workshops throughout the city. The workshop of Verrocchio (where Leonardo was a student and where Botticelli, Perugino and a great many lesser artists worked) and that of Ghirlandaio (where Michelangelo studied) were the two most famous in the city. This then was the artistic climate of Florence, where the stimulating presence of the Medici family was felt by all artists, and where Sandro Botticelli's artistic expression developed.

The work which can most reasonably be considered as typifying the relationship between the Medici family and the artist is the *Adoration of the Magi*, now in the Uffizi Gallery. According to scholars, this was commissioned between 1475 and 1478 by Giovanni (or Gaspare) di Zanobi Lami, a banker with close ties to the Medici family who wanted it placed on his family altar in the Church of Santa Maria Novella. The main attraction of this painting, as far as critics are concerned, is the fact that it contains so many portraits of historical characters. But all this should not lead us to ignore the outstanding compositional accomplishments which show how much Botticelli was by this time master of his own art.

His art also unifies the elements taken from other painters and the expression of melancholy pride, to be seen even in the self-portrait in this painting, gives the entire work that sense of fairy-tale meditation which will be a constant feature of all his later work. We must also mention some of the identifications of characters in the painting with real historical figures (see caption).

As far as the painting itself is concerned, we can add that it is drawn with a striking fluency of line and that the golden coloring, rather like a beautifully calm dusk, is one of the most outstanding Botticelli was ever to achieve, recreating in a more complex but more spacious background the atmosphere of the two Stories of Judith.

Probably associated with the painting of the *Adoration of the Magi* is the frescoed lunette with the *Nativity*, now to be found on the internal facade of Santa Maria Novella above the entrance door. Its original location was on high, crowning the chapel (or altar) built by Gaspare Lami in the church's internal facade. It was a singular fate that caused both its position and form to change, since after its removal it was replaced by Masaccio's fresco of the *Trinity* which today we see back in its original position on the wall to the church's left nave.

The lunette, which was rounded, was detached

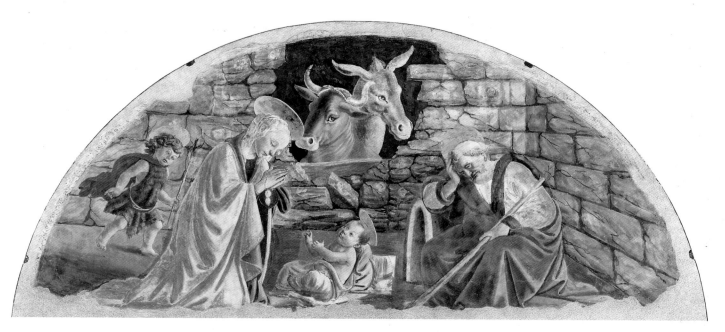

20. *Birth of Christ*
200 x 300 cm
Florence, Church of Santa Maria Novella

21. *Portrait of Giuliano de' Medici*
54 x 36 cm
Bergamo, Accademia Carrara

22. *Portrait of a Young Woman, called "Simonetta"*
61 x 40 cm
Florence, Galleria Palatina (Palazzo Pitti)

in the 19th century, fixed to a lathwork support and given an ogival shape to adapt it to the ogival frame of the ornamental panel above the door. Obscured by repaintings, it was carefully restored in 1982 by the Opificio delle Pietre Dure. It was revealed to be a simple composition, although one with extraordinary expressive force: the same enclosed space of crumbling squared stones that also appears — though in a broader perspective — in the Uffizi altarpiece. A light colouring, with golden ochres, dazzling azure blues and the vermilion of the young St John's fluttering cloak, constitues the fresco's chromatic *leit-motiv*. Although his pose is different, the physiognomy of the pensive St Joseph is reminiscent of the one in the painting with the *Adoration of the Magi*; the face of the Virgin still shows traces of the influence of Filippo Lippi, though with that vein of softness so peculiar to Botticelli. Even the ox and the ass — so masterfully juxtaposed — participate in the feeling of satisfied admiration present in the scene. The recent restoration has now made it possible to banish definitively the doubts of those critics who have questioned the painter's autography. Here (and it must be in the years 1476-78, the same years to which the altarpiece of the Lami chapel belongs), the artist reveals his talents as a fresco painter, the previous evidence of which had been scanty and inconsequential.

At about the same time, in the summer of 1478, the Republic, by now in the hands of the Medici, asked Botticelli to paint the portraits of the conspirators who had murdered Giuliano on the northern wall of Palazzo Vecchio. He also painted at least one portrait of Giuliano himself — one before Giuliano's death, and perhaps others later. There are many versions, none clearly identifiable as by

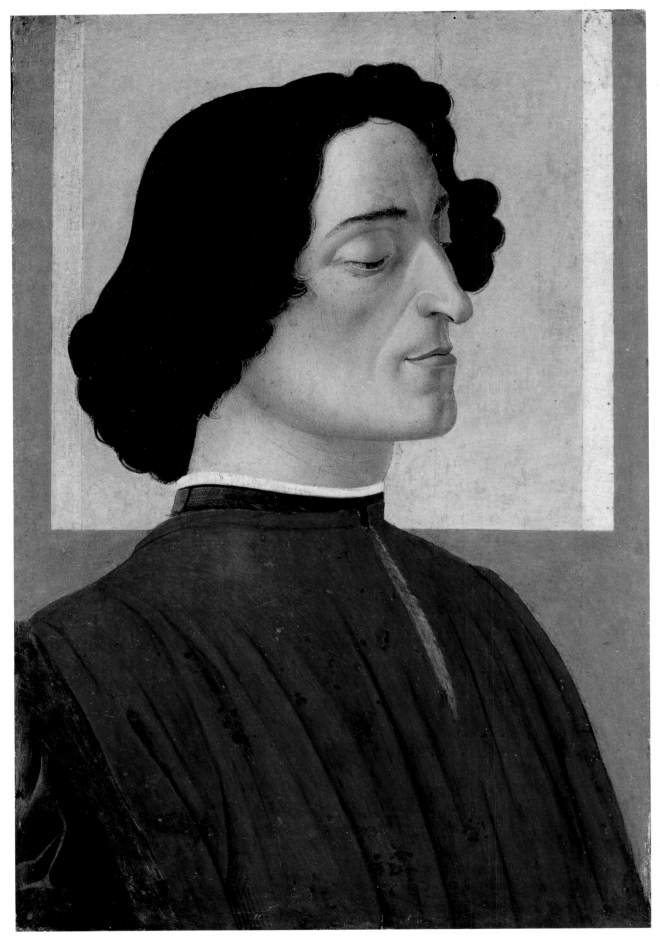

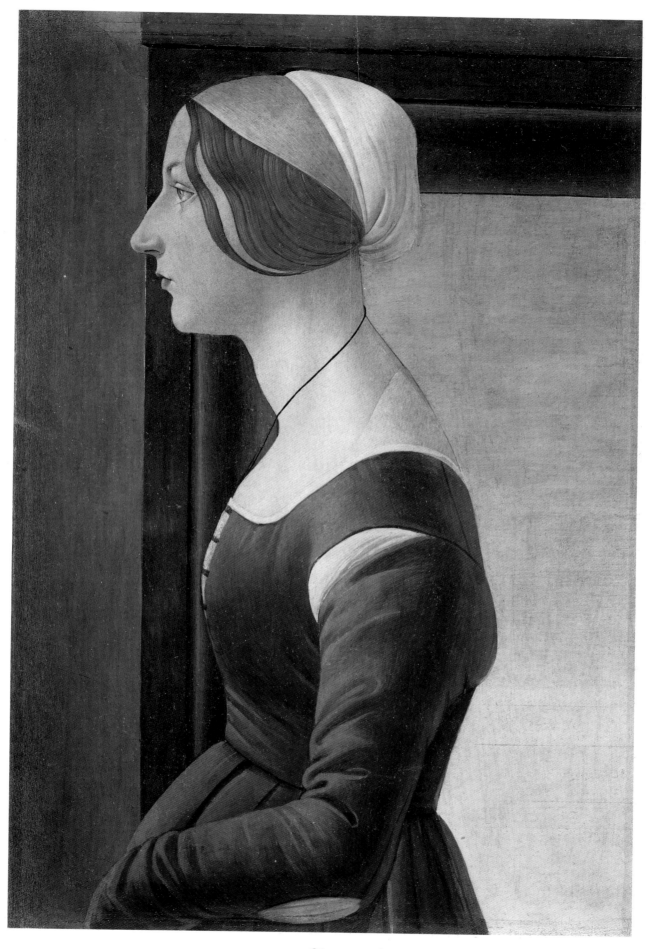

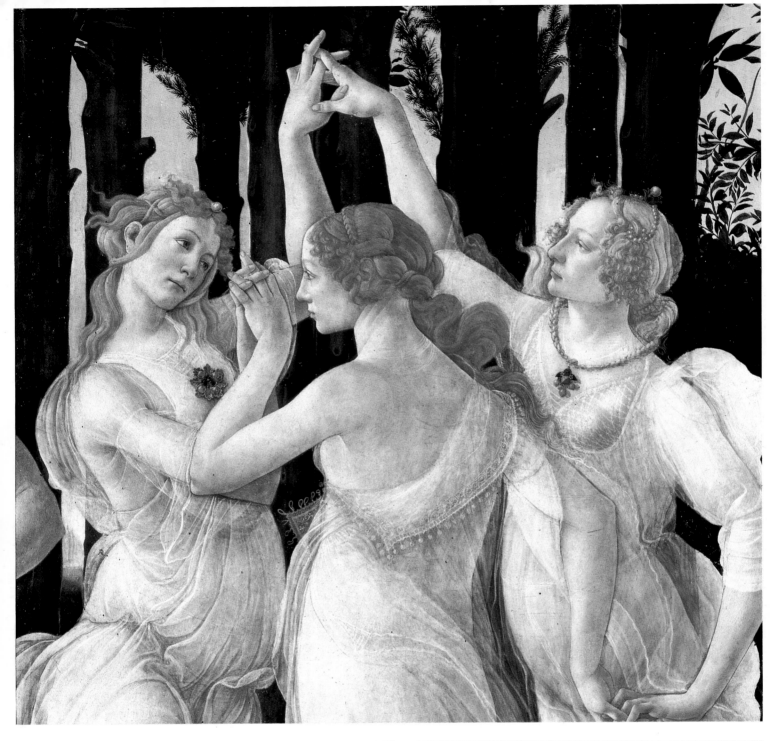

23, 24. *Primavera*
details of the Three Graces
Florence, Uffizi

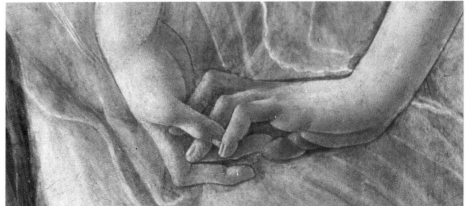

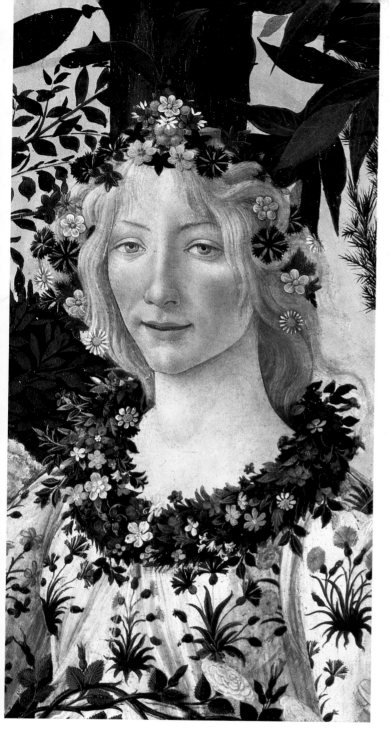
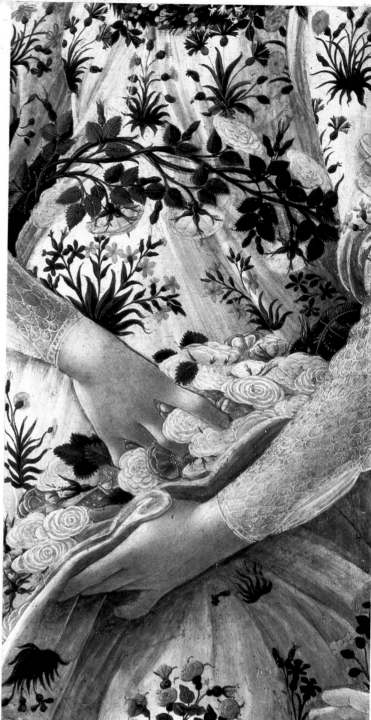

25, 26. Primavera
details of the goddess
Florence, Uffizi

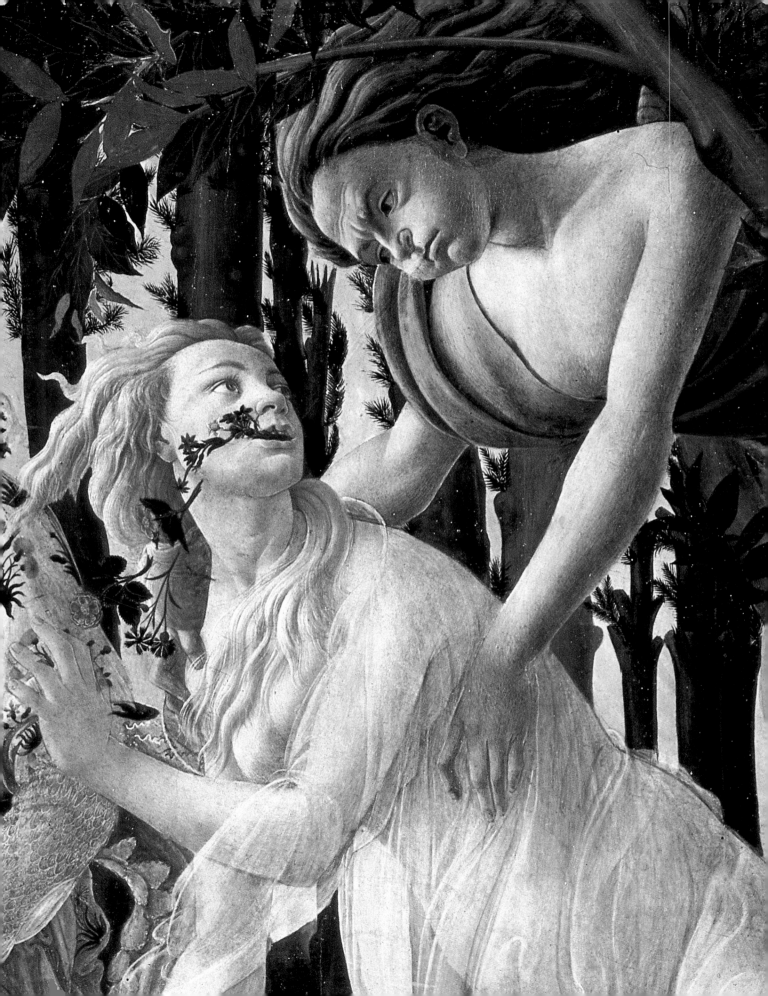

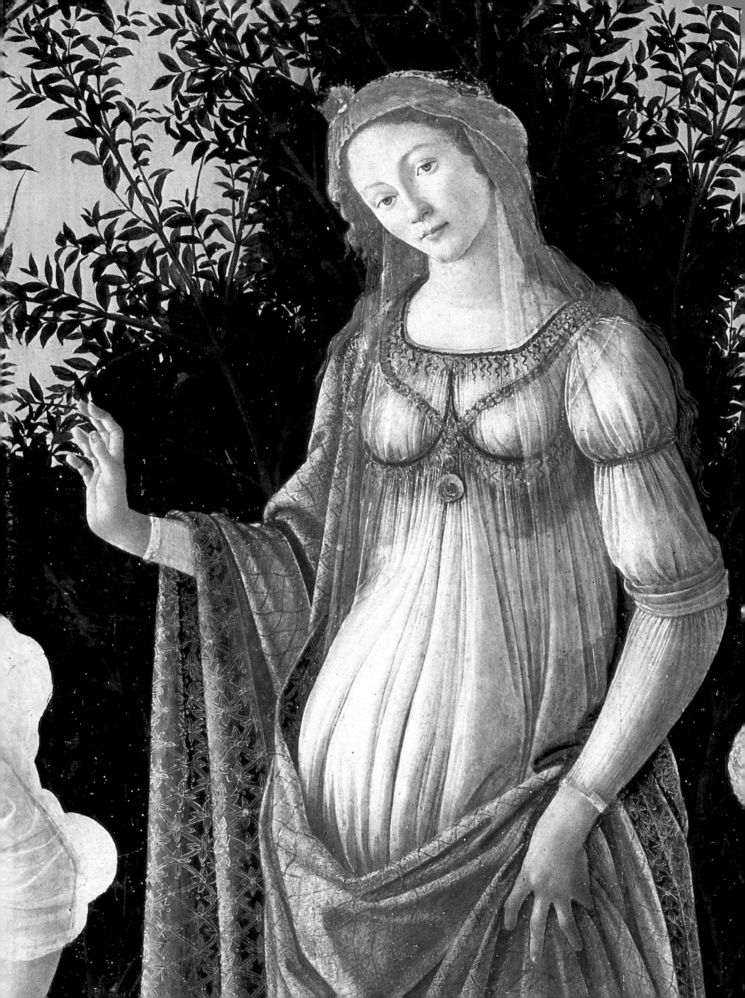

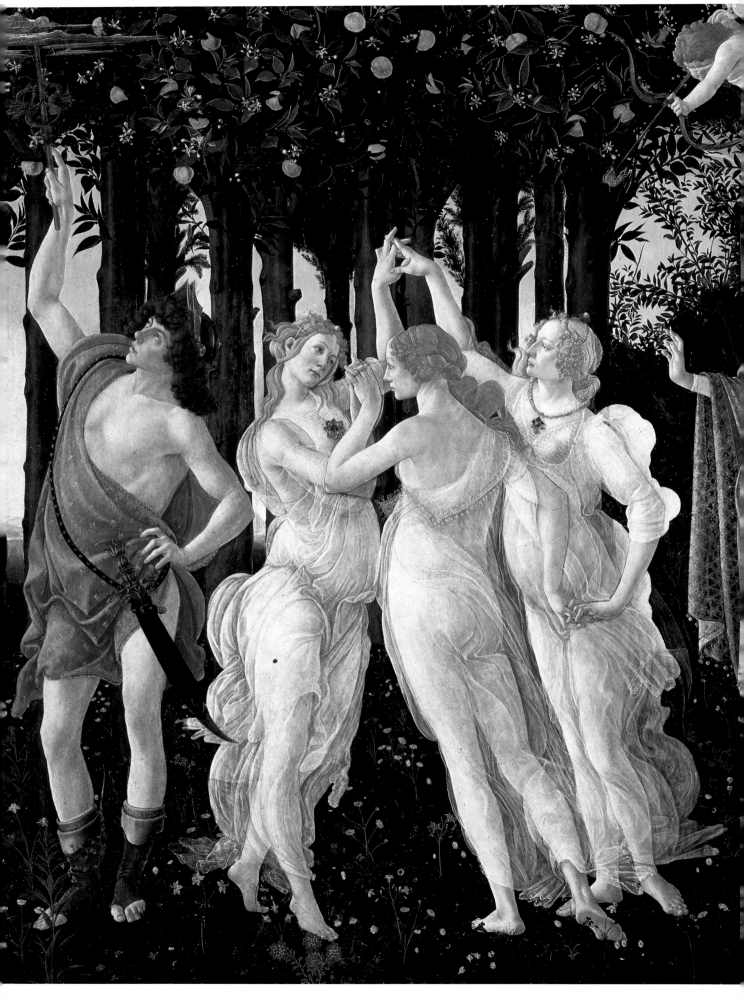

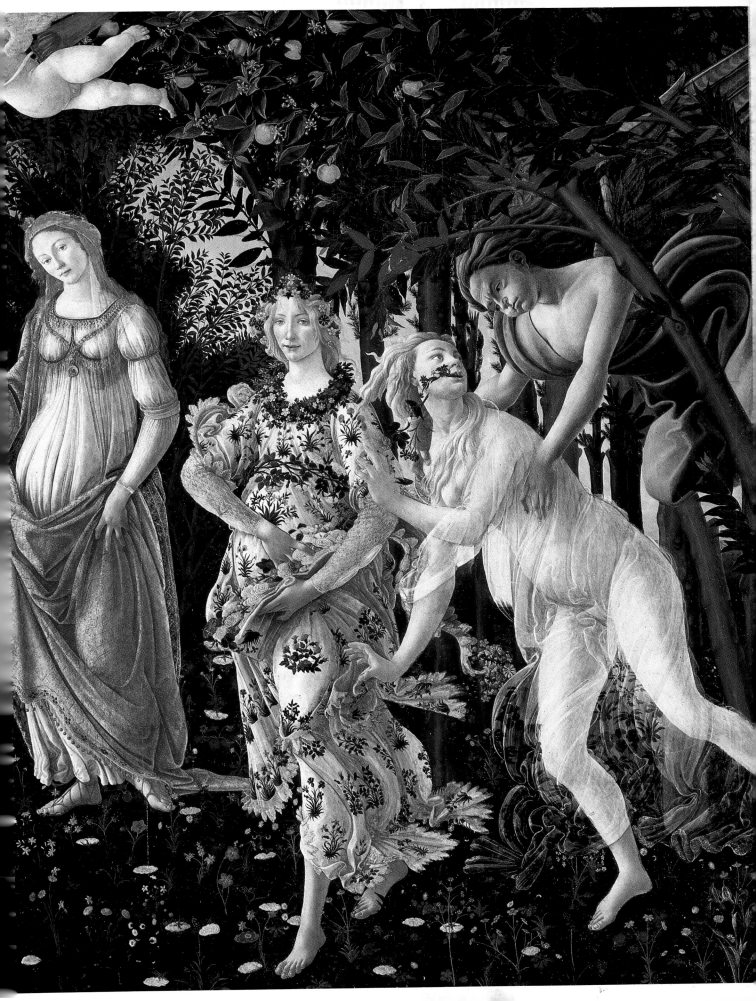

Botticelli. It is also difficult to establish which one of these is the earliest, because of their terrible state of preservation. What is certain is that it is around this time that Botticelli passed from group representations of people to individual portraits, while still maintaining that primary quality of melancholy which justifies the phrase 'sadness of exile', so often used to describe the characters in his paintings. There is another portrait which can be dated to around this period, that of *Simonetta* in the Pitti Palace. Although the identification with Simonetta, the young girl with whom Giuliano was in love, is probably only the result of legend and not of fact, the subtle melancholy which pervades this clearly-designed figure is undeniable proof that it is the work of Botticelli. It is this very uncertainty about the real identity of the figures in these portraits that increases their effect of mystery.

Sandro Botticelli's two most famous works, the so-called *Primavera* (Spring) and the *Birth of Venus*, were both commissioned by the Medici. The two paintings are admirable products of the cultural environment created by Medici patronage. The critics are all in agreement about the years in which they were painted: 1477-1478. They were painted for the brothers Giovanni and Lorenzo dei Medici, the sons of Pierfrancesco who was the first cousin of Piero 'the Gouty'. This branch of the family later rebelled against the absolute rule of Piero di Lorenzo and earned the nickname of 'the Medici of the people'. It was to this branch that the Grand Dukes belonged. Lorenzo, the son of Pierfrancesco, had been a pupil of Marsilio Ficino and he commissioned from Botticelli some frescoes for his villa of

Castello, where he also wanted to place the two famous paintings. Lorenzo's Neo-Platonist training is important in attempting to explain the subject-matter of these paintings. Marsilio Ficino was the greatest representative in fifteenth-century Florence of this philosophy which followed the teachings of Plato, revised in such a way as to fit in with Christian doctrine. There have been many interpretations about the origins of the subjects of the two works, including some which see them as deriving from classical poetry, in particular from the work of Ovid and Horace. It also seems possible that the inspiration could have come from the work of Ficino himself, developed artistically by the poet Poliziano, and that Venus, instead of symbolizing the carnal nature of pagan love, might be the representation of the Humanist ideal of spiritual love, that is "those conscious, or semi-conscious, upward movements of the soul, through which all is eventually purified" (Chastel). It is therefore a cosmological-spiritual representation, in which Zephyrus and Flora give birth to Spring, the central symbol of the creative capacity of Nature. In the center of the *Primavera*, with blind-folded Love above her, is Venus, identified with *Humanitas* — the sum total of man's spiritual activities; with her are the three Graces, who represent these activities put into practice, while Mercury disperses the clouds with his staff. This mythological representation is given strength and life by Botticelli's style and by the mastery with which he was able to create in the background an orange grove moved by the same dance-like rhythms as the clothes of the figures stirring in the breeze. The figures stand

27-31. Primavera
203 x 314 cm
Florence, Uffizi

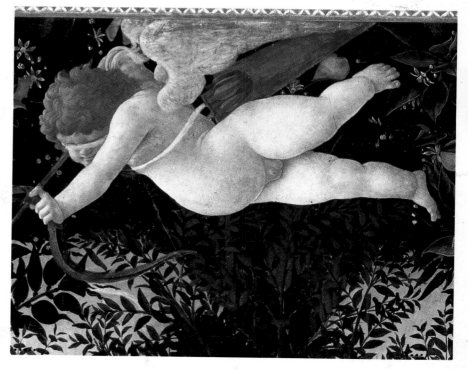

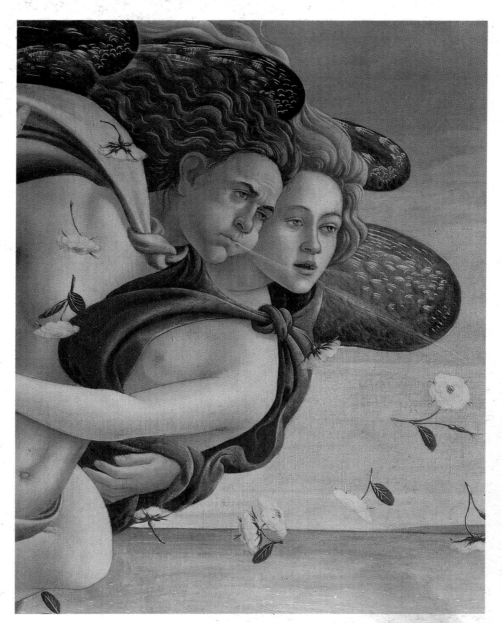

31

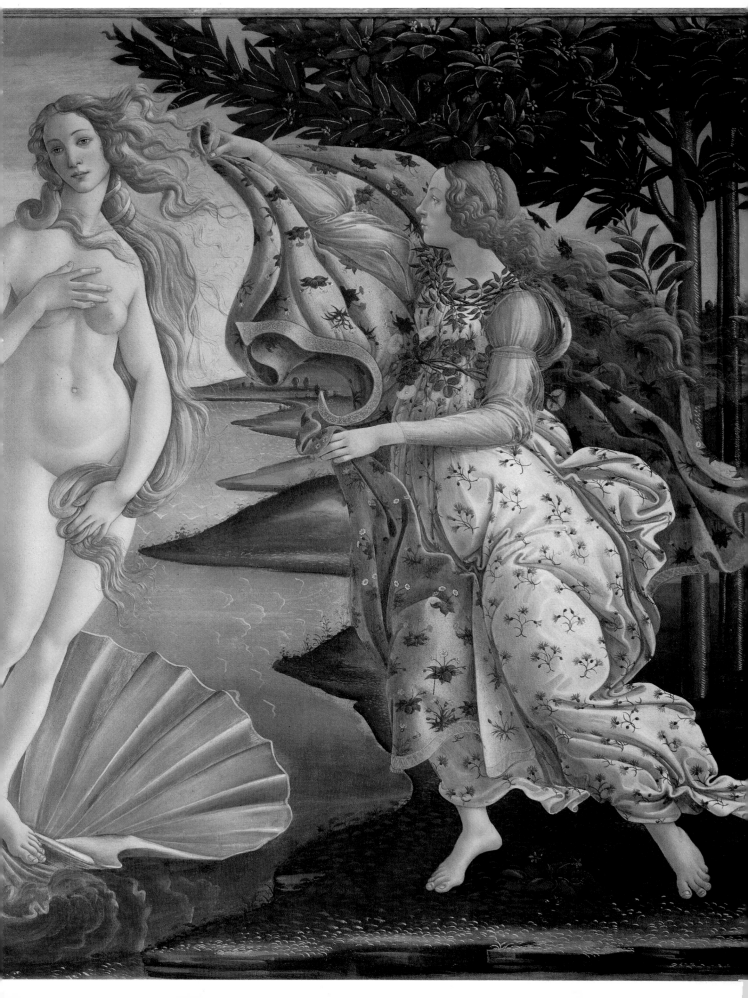

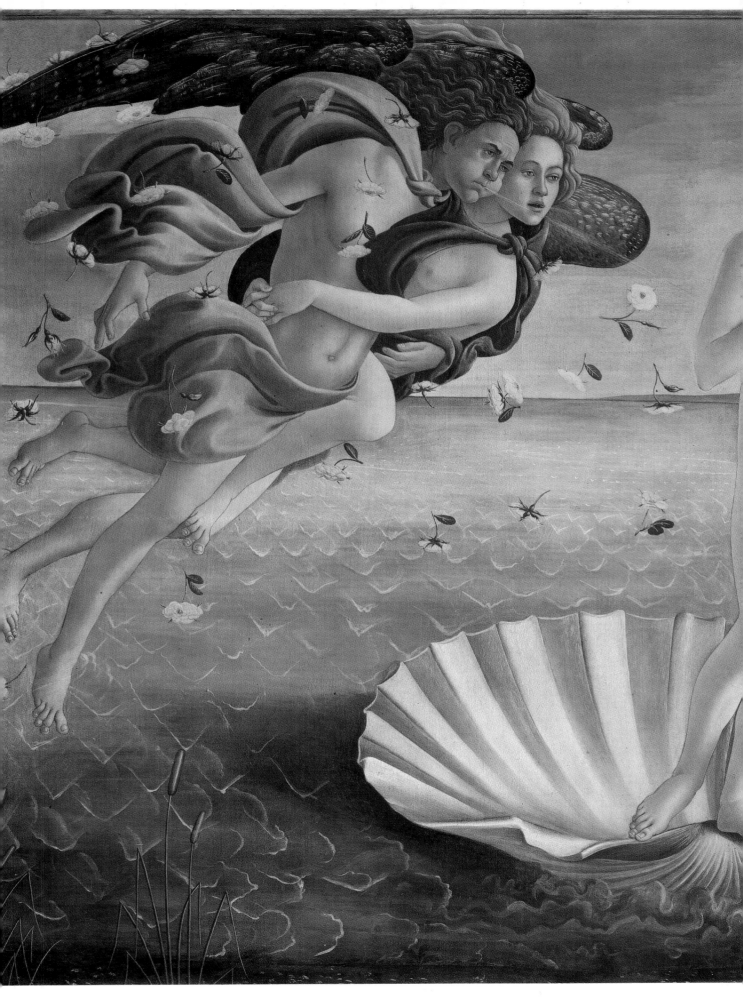

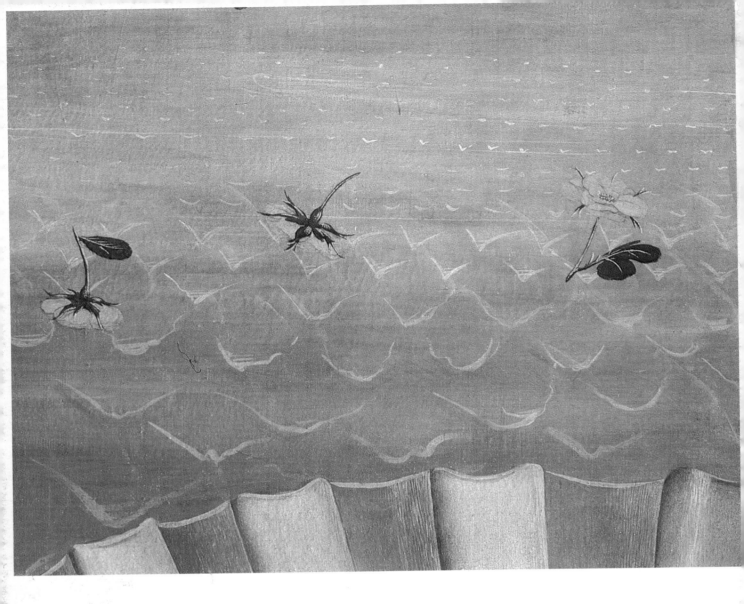

out clearly against the background of dark leaves, creating an effect similar to that of a tapestry. Some critics have seen in all this a return to Gothic fantasy, but it is more sensible to see it as the first successful attempt in the early Renaissance at placing figures freely in space.

The *Birth of Venus* also has the same basic setting and it portrays the preceding moment in the development of the Neo-Platonist myth: *Humanitas* is about to be created by Nature, while the life-giving spirit, united with matter, gives it vital force and the Hour (or Time), symbolizing the historic moment of humanity, offers her the cloak which will make her 'modest' and able to distribute goodness. This painting is probably what Poliziano is referring to in the lines from his *Stanzas*: "A maiden not with a human face / pushed forward by lustful Zephyrs / stands on a shell; and the Heavens enjoy the sight". Remarkable is the way in which the delicate colors of dawn are portrayed in the flesh-tones of the figures rather than in the

36, 37. Birth of Venus, details
Florence, Uffizi

32

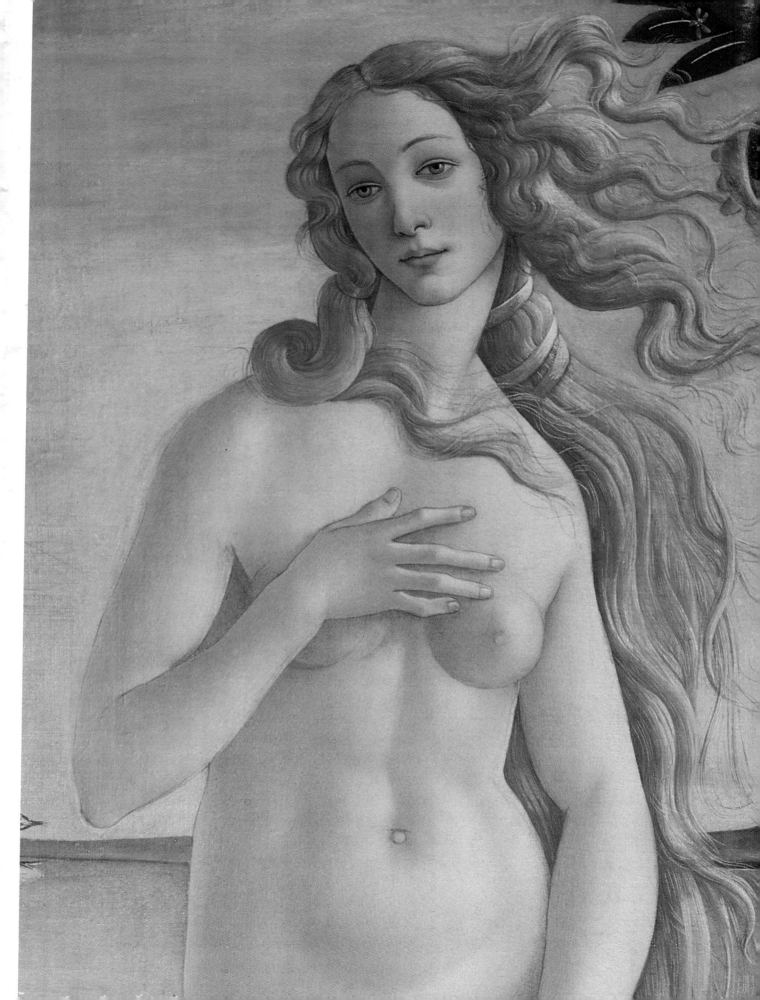

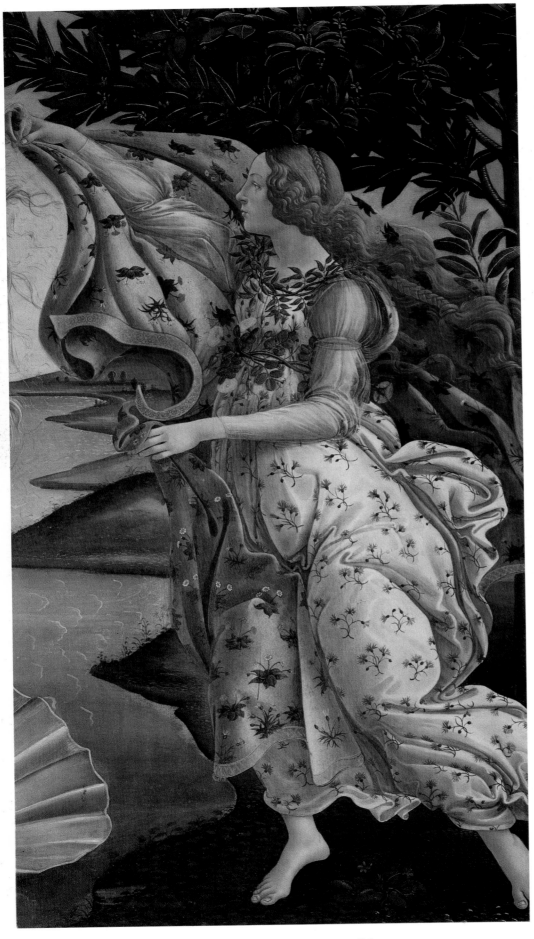

38. *Birth of Venus
detail of Hour
Florence, Uffizi*

39. *Nastagio degli Onesti
(first episode)
83 x 138 cm
Madrid, Prado*

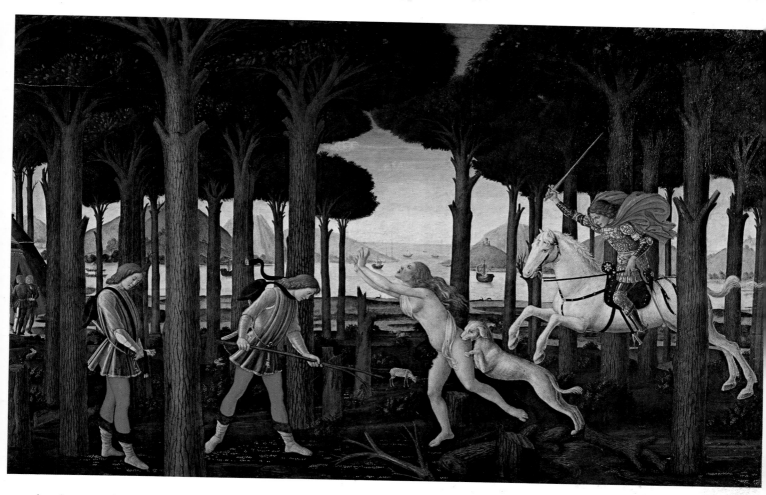

background, and in the colors of the clothing, so delicate and enlivened by the decorations of corn-flowers and daisies. The optimism of the Humanist myth is here blended harmoniously with the calm melancholy so typical of Botticelli's art. After two paintings, the conflict of conscience which had overtaken the cultural and figurative values of the Renaissance involved Botticelli as well in ways that we are about to see. The first traces of this can be noticed as early as the 1480s.

Lorenzo the Magnificent commissioned Sandro to paint four episodes from the story of Nastagio degli Onesti in Boccaccio's *Decameron*. The subject-matter of this story is at once fierce and chivalric, similar to the 'courtly' culture which centred around Lorenzo. The occasion for these paintings was the wedding of Giannozzo Pucci, Lorenzo's nephew, to Lucrezia Bini. The first three of these panels are now in the Prado in Madrid and the fourth is in the Watney Collection in Great Britain. Until the second half of the last century all four of them were still in the possession of the Pucci family.

The conception of these four panels is entirely Botticelli's, even though — as was quite frequent in those days — a large part of the actual painting was left to the workshop. The first three scenes show very clearly the hand of Bartolommeo di Giovanni and the last one that of Jacopo del Sellaio, both of whom were very close followers of Botticelli. The most pleasing effect of the works is produced by the harmonious background settings, both in the episodes that take place in the pine-woods of Ravenna and in the scene of the banquet for Nastagio's wedding to the daughter of Paolo Traversari. As was by this time customary in Botticelli's paintings, drama and formal elegance (exemplified in the agility of the figures and in the graceful movements of people and animals) blend together to give us the impression of a story half way between reality and fantasy, here enlivened by the pure colors of the architecture and by the subdued representation of nature.

In the spring of 1481 Botticelli frescoed on a wall of the Hospital of San Martino alla Scala an *Annunciation*, which is now in one of the vestibules of the Uffizi. The power of his art is here expressed at its best in the angel who arrives with his clothes billowing and the lily in his hand bent by the wind. Opposite the angel, the Virgin leans forward with that air of resigned submission which seems to foreshadow those figures prostrate with grief that recur in Botticelli's later work. The perspective is also used as a method of expression, so slanted in the

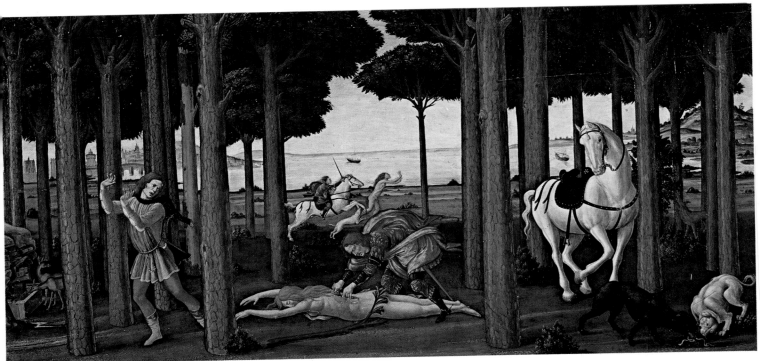

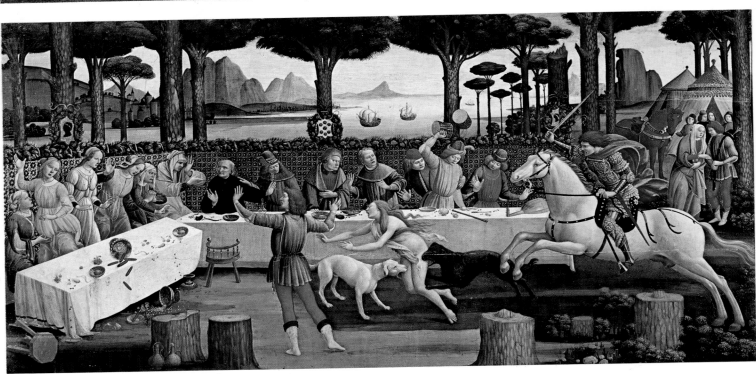

foreground and with the almost unending background.

As we have already mentioned, Botticelli was given the task of painting the members of the Pazzi conspiracy of 1478 on the walls of Palazzo Vecchio. It has been suggested that he was inspired in this by the paintings of hanged men by Andrea del Castagno in the Bargello: they were also members of a conspiracy against the Medici, the Albizzi conspiracy. After this work, of which there is no longer any trace, Castagno's influence on Botticelli can be

40. *Nastagio degli Onesti (second episode)*
82 x 138 cm
Madrid, Prado

41. *Nastagio degli Onesti (third episode)*
84 x 142 cm
Madrid, Prado

42. *St Augustine*
152 x 112 cm
Florence, Church of Ognissanti

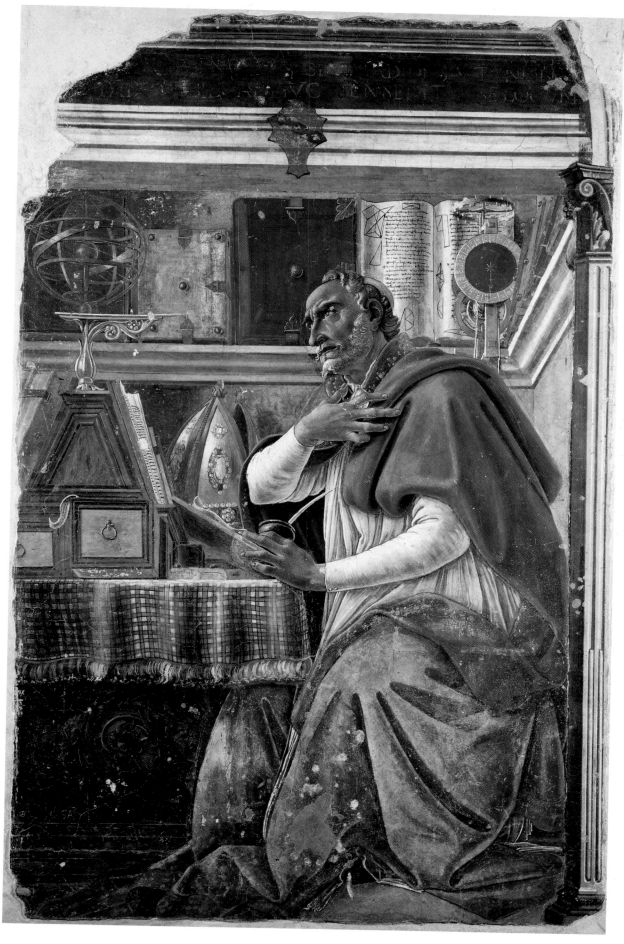

seen in the powerful figure of *St Augustine* in the Church of Ognissanti, painted for the Vespucci family, who were close friends of the Medici. Since this figure stands together with the *St Jerome* painted by Ghirlandaio in 1480, we can deduce that they were part of a single commission and were painted in the same year. The outstanding energy of Andrea del Castagno's work is transformed by Botticelli into a prevailing mood which is full of restlessness and apprehension. One can begin to see in Sandro's work that tension which has been ascribed to a conflict of conscience after the bloody events of 1478, which certainly undermined the idyllic Humanist atmosphere created by the Medici. This work probably marked the height of Botticelli's fame as an artist and in 1480 he was called to Rome together with Cosimo Rosselli, Perugino and Ghirlandaio (and later also Pinturicchio, Piero di Cosimo and Signorelli) to paint stories from the lives of Moses and Christ on the walls of the Sistine Chapel. These were commissioned by Pope Sixtus IV, the traditional rival of Lorenzo the Magnificent; but there must have been a reconciliation between the two if so many Florentine painters, including Botticelli who could be called the official interpreter of Medici patronage, were summoned to Rome. In October 1482, as we have already mentioned, Sandro was again in Florence to decorate the Sala dei Gigli in Palazzo Vecchio.

There are still three enormous frescoes by Botticelli on the walls of the Sistine Chapel. These are *Scenes from the Life of Moses*, the *Temptation of Christ* and the *Destruction of the Children of Korah*. He also painted, with much help from his workshop, in the niches above the biblical scenes, some portraits of popes which have been considerably painted over. In all these works his painting appears weak and only in the first of the frescoes does he succeed in co-ordinating the formal with the narrative. In the rest he manages to express his usual vigor in the portraits only, whereas the whole appears fragmentary and lacks genuine quality. Probably the painter, working in a different environment, on subject-matters and in dimensions so unusual for him, felt lost and had difficulty in expressing his art to the full.

But when he returned to Florence he started working again with his customary sureness of hand, also incorporating some figurative elements acquired during his stay in Rome. The painting of *Venus and Mars*, today in the National Gallery in London, obviously derives from classical art and probably from the very same Roman sarcophagus which was also to provide the inspiration for the face of the centaur in *Pallas and the Centaur*. The painting of *Venus and Mars* can probably be dated around 1482-1483, and like many of Botticelli's works has been subject to many different interpretations. Venus, calm and self-assured, watches the sleeping Mars, while little fauns playfully rush about the scene. This can all be connected with Humanist themes: Venus as the personification of love conquering Mars, who symbolizes discord. Despite the playful element of the fauns, the dominant mood of the painting is not serene: the sleeping god is fatigued and his body is almost too relaxed; Venus's expression is slightly restless and worried. This same feeling we can find again in the *Portrait of a Man*, probably painted around the same time (1483-1484), now also in the National Gallery. The face and the tense lines express a greater apprehension than in the *Portrait of a Man with the Medal of Cosimo the Elder*, mentioned above. Both portraits are typical of Florentine portraiture, but Botticelli's are different in mood from the celebrative portraits of the 1480s: they have another feel about them, something more subdued but at the same time more human. He seems to want to convey in this work a cautious analysis of his personal feelings.

In 1482 he painted for Lorenzo dei Medici, son of Pierfrancesco, *Pallas and the Centaur* — today in the Uffizi — perhaps intended as the third and concluding work of the trilogy begun by the *Primavera* and the *Birth of Venus*. For this painting too, many different interpretations have been put forward. That which is commonly regarded as most plausible again fits in with Humanist symbolism: wisdom (Pallas) overcomes instinct (the centaur), concluding the conceptual definition of *Humanitas* present in the other two allegories. The strong and vigorous figure of Pallas can be traced back to classical sculpture and, as we have said, the Roman sarcophagus which inspired the face of the centaur has been identified. The entire composition is characterized by great elegance, brought about by the rhythm of the line and by the physical relationship between the figures and the rocks "which form an orderly and solid architecture similar to the ruins of Rome" (Salvini). If we consider this painting the last of Botticelli's Medicean period, as is the general opinion of art-historians, we can see that from this point onwards the subject-matter of his paintings changes and becomes increasingly religious. The pictorial technique changes too: the colors become purer and more striking in order to accentuate even further the expressionism of the scenes; the contorted positions and shapes of the figures emphasize the exasperation of their movements and their gestures.

We must not underestimate the importance of the personal evolution of the painter's style, com-

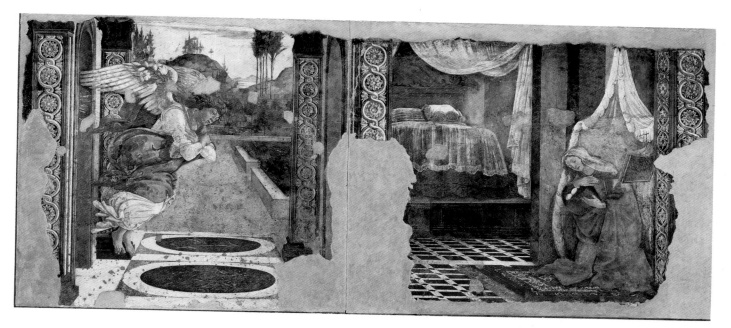

43. Annunciation
243 x 550 cm
Florence, Uffizi

mon to many artists, in explaining away these transformations: that is to say, a development from the more tempered compositions, typical of the central phase of an artist's work, to the more elaborate and complicated forms, especially psychologically, of the later period. But personal artistic development, in Botticelli's case, was not the only reason for this evolution. The events of 1478 (the Pazzi conspiracy) certainly shook not only the Medici's power, but also the consciences of the most politically aware citizens of Florence. And even though until 1492 no internal force endangered the political stability of the Republic, certainly in the minds of more sensitive people, such as Botticelli, doubts concerning the contemporary situation must have begun to grow.

The painting of *Pallas and the Centaur*, as we were saying, marks the end of Botticelli's Medicean period. It is also the end of a very serene and prolific period in the artist's career, considering the variety and quantity of the works produced.

The policital situation changed with the death of Lorenzo the Magnificent in 1492 and the invasion of King Charles VIII of France in 1494. Piero di Lorenzo, son of the Magnificent, was forced to flee from Florence and the family temporarily lost power. The sentiments expressed in Botticelli's art also changed and this caused it to take on new directions and show new concerns. In the cultural atmosphere of declining Humanism, the complex personality of Fra Girolamo Savonarola appeared on the Florentine political scene.

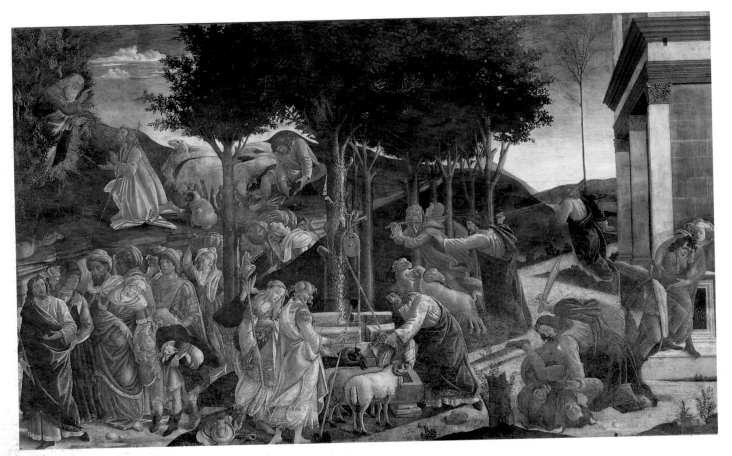

44. *Scenes from the Life of Moses*
348 x 558 cm
Vatican, Sistine Chapel

45. *Scenes from the Life of Moses*
detail of Moses taking off his
shoes

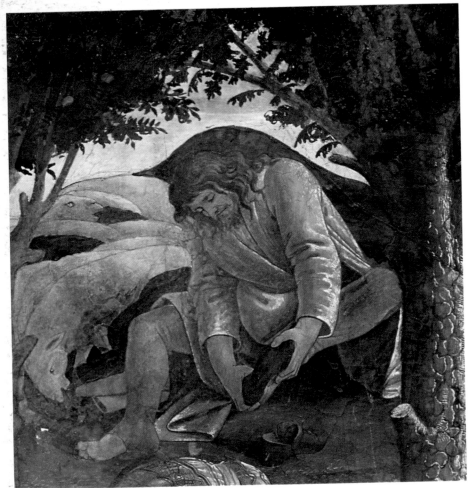

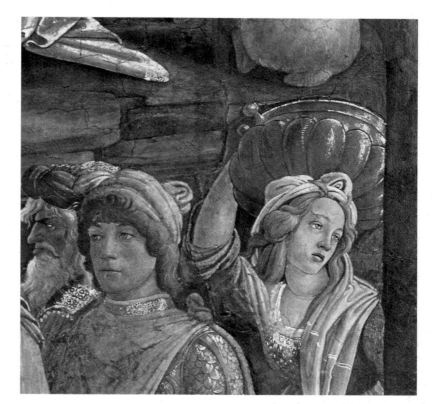

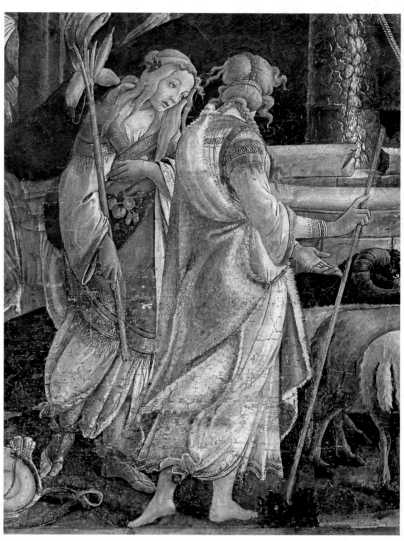

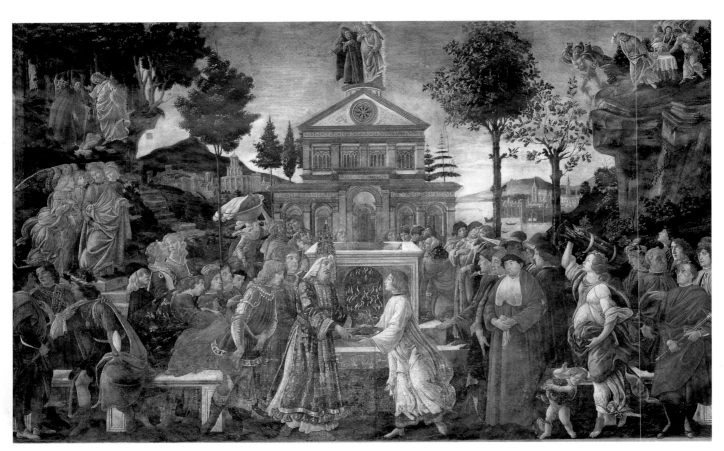

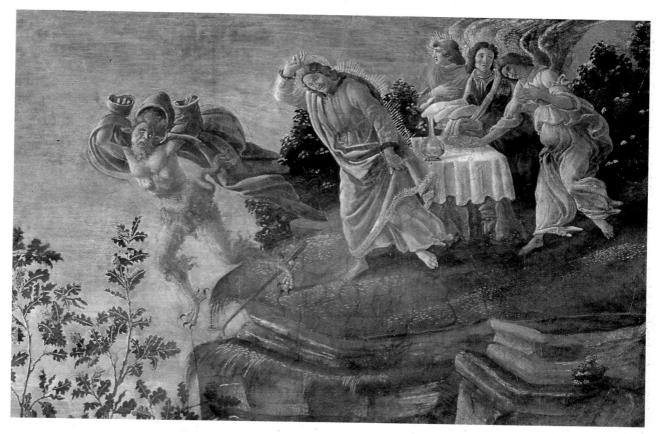

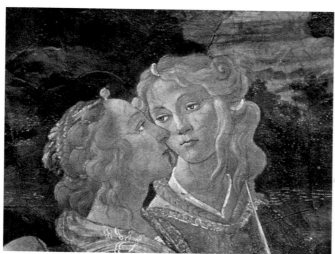

48-52. *Temptation of Christ*
345.5 x 555 cm
Vatican, Sistine Chapel

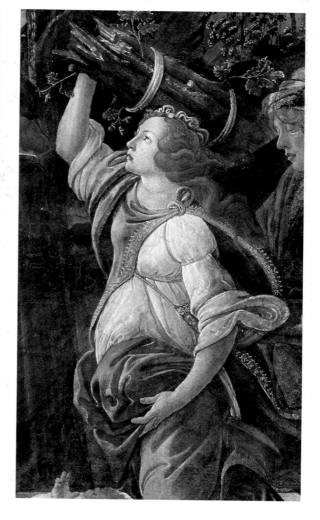

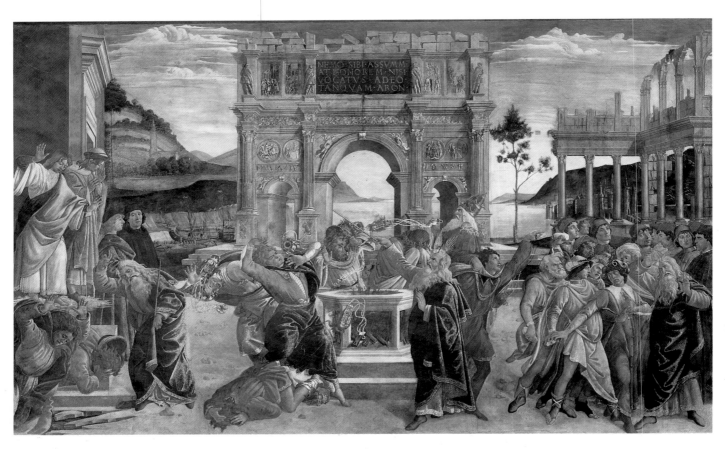

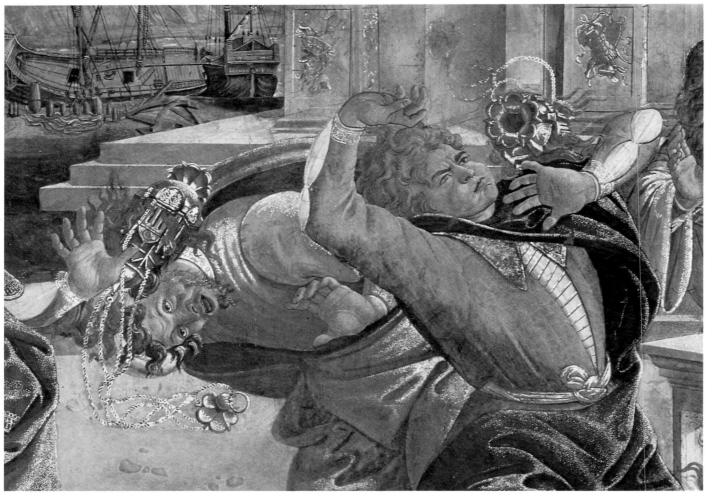

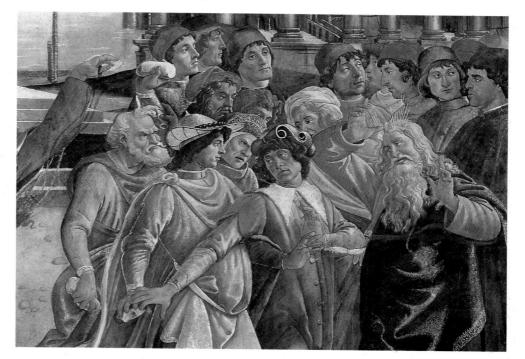

53-56. *Destruction of the*
Children of Korah
348.5 x 570 cm
Vatican, Sistine Chapel

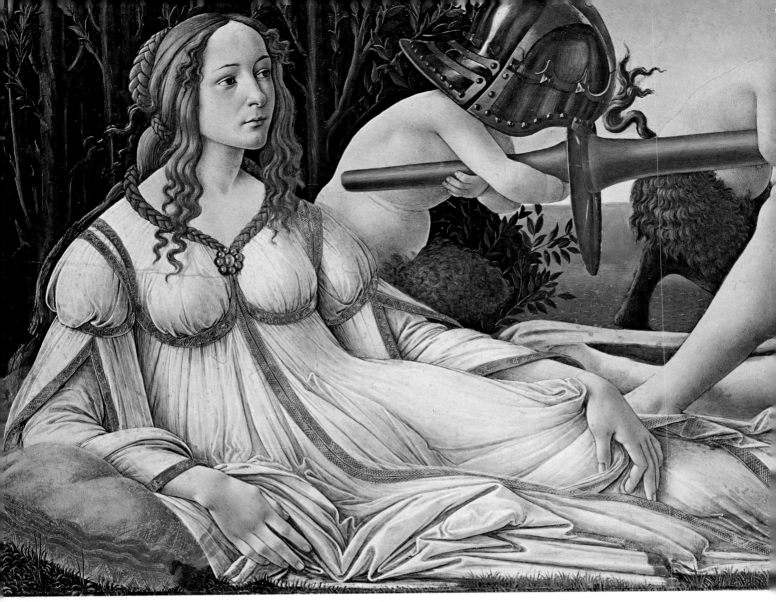

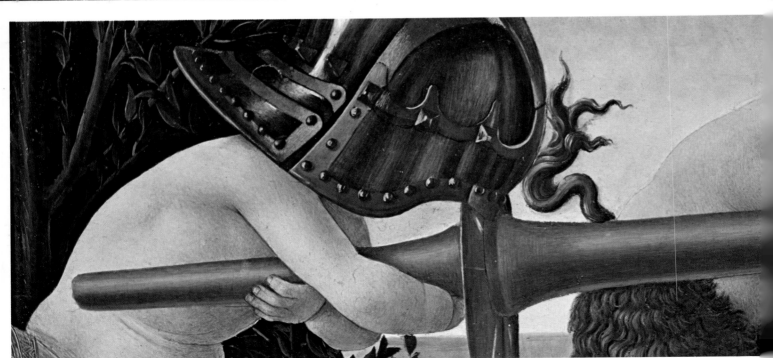

far as subject-matter is concerned and also because of some artistic innovations. This painting is usually dated immediately after Botticelli's return from Rome. But while the vaguely Umbrian landscape, with its tall slender trees, can be attributed to the influence of Perugino, the group of graceful figures have a more abstract air about them than, say, in the *Adoration* in Florence. The artist is working toward forms of greater expression which will be fully revealed in later works.

The *Madonna of the Book* in the Poldi-Pezzoli Museum in Milan belongs to the period around 1485. It is a small painting, dominated by the precise contours of the Virgin and Child, in whose faces one can see a relationship of deep affection coupled with the customary expression of serene melancholy. The dramatic intensity not expressed through the figures is suggested by the crown of thorns around the tender arm of the Christ Child. Of a different intonation is the well-known *Madonna of the Pomegranate*, painted in 1487 for the Florentine Magistratura dei Massai di Camera. The representation of figures is the dominant part of this work, so that even the special perspective is created by figures of angels who surround the Virgin and the blessing Child in a semi-circle. The probable link between these two paintings is the tondo called the *Madonna of the Magnificat*, now in the Uffizi, that critics have dated to around 1485. The slightly oval face of the Virgin is very similar to that of the *Madonna of the Book*. The scene is painted against the slightly unusual background of a round window, almost like the oculus of a church: this innovation, so typical of Botticelli's art, nevertheless bears a vague resemblance to Lippi's work, especially in the poses of the angels. The use of gold and the faraway landscape are wonderful examples of great artistry.

This painting was followed by the Madonna Enthroned with St John the Baptist and St John the Evangelist, commonly known as the *Bardi Madonna* because it was painted towards the end of 1485 for the Church of Santo Spirito on a commission by Agnolo Bardi. Today it is in the Staatliche Museen in Berlin. The composition is static and the only sense of movement is created by the elaborate

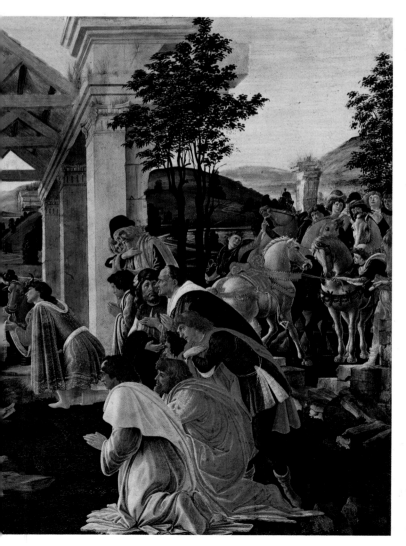

62. Adoration of the Magi
70 x 103 cm
Washington, National Gallery of Art

51

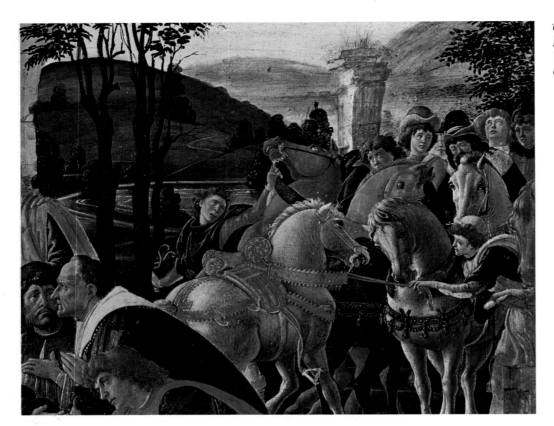

floral background, consisting of plants with symbolic meanings which refer to the incarnation and passion of Christ (lilies, olive branches, laurel leaves and palms). The figure of the Virgin is taller here, and her features are more ascetic. The painting is enlivened by the vivacious movements of the Child to which Mary responds with the instinctive maternal gesture of offering her breast. We can see through these figures a very definite tension, a prelude to some of Botticelli's later works. But in the meantime another very important organization in Florence, the Guild of Doctors and Apothecaries, commissioned from the artist a very grand altarpiece. It is the so-called *San Barnaba Altarpiece* (Madonna enthroned with St Catherine of Alexandria, St Augustine, St Barnabas, St John the Baptist, St Ignatius and St Michael), commissioned for the Church of San Barnaba of which the Guild was the patron. Scholars have dated this painting to 1486. Today it is in the Uffizi. The architecture, both concise and majestic, seems to point towards the art of the sixteenth century, and it is certainly the best example of Botticelli's mastery in this field. At the sides of the curtain, very finely drawn in little tondos, are the two figures of the Annunciation, the Virgin and the Angel. The angels on either side of the tall throne carry the crown of thorns and the nails of the cross, symbols which refer to the passion of Christ. The delicate figure of the Virgin is similar to that in the *Bardi Madonna*, but here the same type of features is also used for St John the

Baptist and for the young warrior Michael, without doubt the most beautiful part of the painting. It must be pointed out that, on the steps of the throne, there is for the first time in the history of painting an inscription in Italian. The line comes from Dante's *Divine Comedy* (Paradise, Canto 33, line 1): "Virgin mother, daughter of your son". This is the first evidence of Botticelli's interest in Dante's poetry, which culminates in his drawings of episodes from the *Divine Comedy*. The *San Marco Altarpiece* (Coronation of the Virgin with angels and St John the Evangelist, St Augustine, St Jerome and St Eligius) was painted around 1488-1490 for the chapel belonging to the Guild of the Goldsmiths in the Church of San Marco. The chapel was dedicated to St Eligius, called 'Alò' or 'Olò' in Florentine vernacular. The composition of the painting is rather archaic in structure, with different proportions used for the saints and for the angels and the imaginative niche where the coronation is taking place contrasted to the realistic space in which the four main figures stand. But the panels of the predella are exceptionally life-like: see, for example, the representation of St John the Evangelist amidst the rocks of the lonely island of Patmos, the figure of St Augustine in his bare study, the concise Annunciation, the rocky cave of the repenting St Jerome, the dynamic figure of St Eligius miraculously restoring his horse's leg, his body twisted in an unusual manner and his cloak billowing in the wind. Reminiscent of Leonardo's

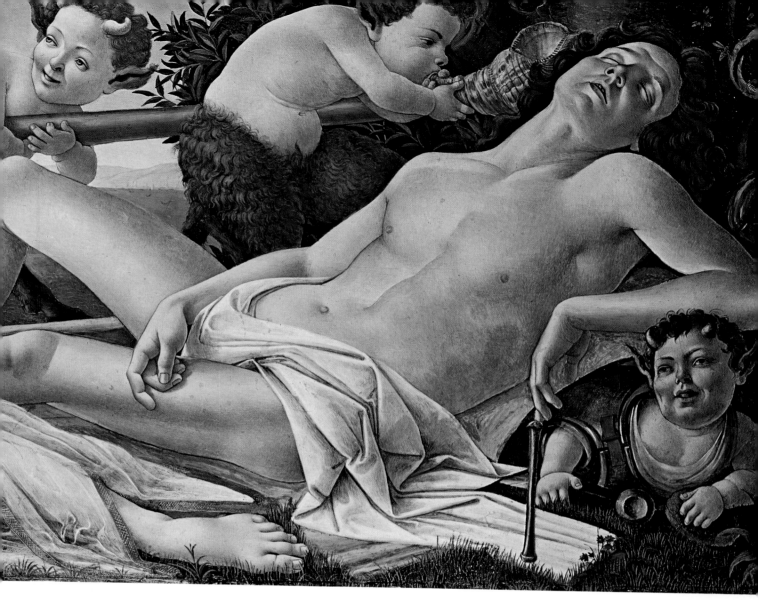

57-59. Venus and Mars
69 x 173.5 cm
London, National Gallery

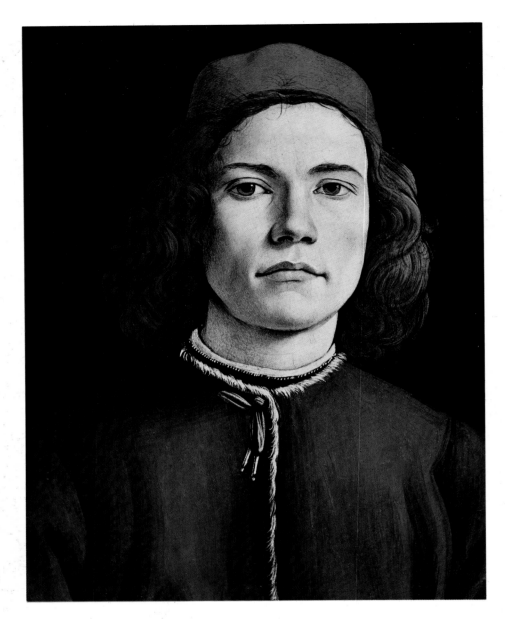

60. *Portrait of a Young Man*
37.5 x 28 cm
London, National Gallery

61. *Pallas and the Centaur*
205 x 147.5 cm
Florence, Uffizi

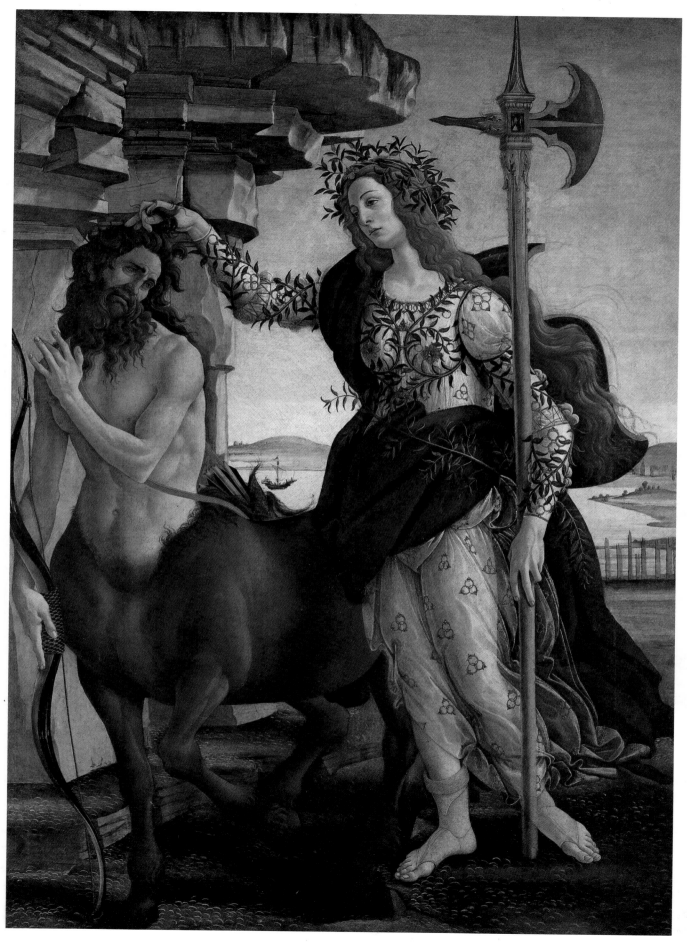

The Age of Savonarola: Pathos and Tragedy

Girolamo Savonarola was born in Ferrara in 1452. In 1475 he joined the Dominicans in Bologna, and very soon became famous for his preaching in the cities of northern Italy. In his impassioned sermons he stressed the need to reform the Church, to destroy its worldliness and nepotism, and to cleanse it of the corruption of the popes. His writings and sermons were full of prophetic tones which could quite well be adapted to present historical conditions. In 1489 he was summoned to Florence by Lorenzo the Magnificent and in 1491 he became Prior of the monastery of San Marco. Here his aversion to the power of dynastic Signorias, which he considered dangerous for the people, soon became obvious. He sponsored demonstrations against all forms of luxury, such as the famous 'burning of vanities', during which — with almost medieval fanaticism — precious objects, elaborate clothes and works of art of pagan content were destroyed by fire. With the invasion of Charles VIII his prophecies seemed to come true and, perhaps for this reason, he played quite an important rôle in the establishment of the Republican government after Piero dei Medici had been exiled. Very soon, however, he was called upon to take back his accusations against Pope Alexander VI Borgia who was well-known for his scandalous behaviour and his corrupt nature. Savonarola's refusal to go to Rome led to his excommunication in 1497. At first the Florentines supported him, but subsequently, out of fear that the entire city might be excommunicated and also because the friar had lost prestige by failing to prove his powers in a trial by fire to which he had been challenged by a rival Franciscan monk, they had him arrested. Then, after a plainly unfair trial, he was sentenced to be hanged and burnt at the stake in Piazza della Signoria, with two of his followers, on 23 May 1498.

Apart from the brief mention in Simone Filipepi's *Cronaca*, in which Sandro shows a certain interest in the fate of Savonarola, there is no other documentary evidence to prove whether or not he was one of the friar's militant followers. But we must note that there are certain themes in Sandro's later works, such as the *Mystic Nativity* and the *Mystic Crucifixion*, which are certainly derived from the sermons of the Dominican, which means that the artist was definitely attracted by that personality so central to the cultural and political events of the city during the last years of the century. And, in fact, it would be impossible to explain away the radical change of subject-matter and even of pictorial style which characterized Botticelli's activity from about 1490 to 1510, the year of his death, without taking into consideration the influence of the preaching of Savonarola. The tendency towards meditation, which ever since his earliest paintings had been an integral part of Sandro's personality and had enabled him to understand and therefore to express in figurative form the Humanist content of Ficino's Neo-Platonism, must have made him more open to Savonarola's principles. It is in this respect, culturally and at the same time psychologically, that Botticelli's acceptance of the Dominican's reform program must be viewed, even though it may not have implied a direct involvement or a political commitment to the Republic created after the Medici had been exiled.

We might consider the *Adoration of the Magi* today in Washington as a typical example of Botticelli's style after the dramatic events of 1478, both as

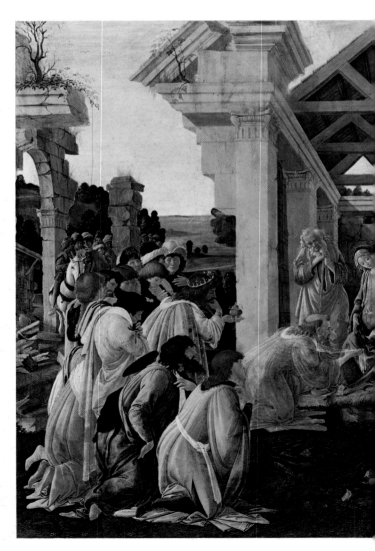

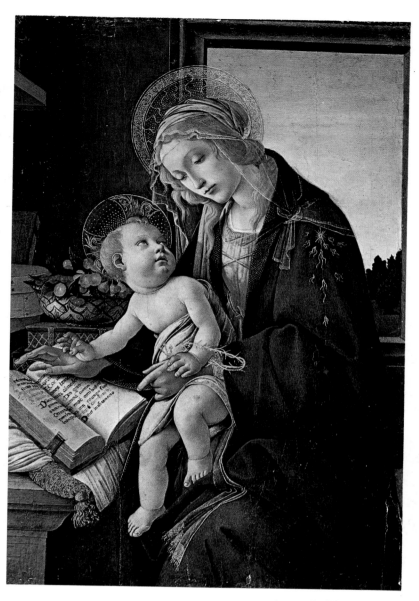

work, and characteristic of Botticelli's ability to blend other artists' motifs into something quite personal, is the white horse. Throughout all these scenes Botticelli's intense emotions are predominant; he bends his figures into contorted positions to express more vividly their feelings.

And yet despite the considerable acclaim which it has received ever since shortly after its execution (it is referred to in Florentine art sources, like Albertini, the so-called *"Libro di Antonio Billi"*, and the *"Anonimo Gaddiano"*, and Vasari himself in both editions of the *Lives*), this large altarpiece has experienced a turbolent history, with numerous changes of location. From the altar of the Church of San Marco it passed to the chapter-house of the convent, from here to the Galleria dell'Accademia and finally to the Uffizi in 1919.

Only with the conclusion of the lengthy restoration, carried out in 1989 in the workshops of the Opificio delle Pietre Dure at the Fortezza da Basso,

can the work's physical and topographical vicissitudes be considered at an end. However, even the recent restoration only partly succeeded in putting to rights the damage caused by this stately painting's wandering through the various buildings that once housed it. The numerous transfers also witnessed the deprecatory loss of the superb original frame, which was subsequently replaced by another, meticulously carved, that came from the dissolved Church of the 'Battilani'. Restorations were made continuously necessary from 1830 (when, still at the Accademia, the painting was restored by Francesco Acciai) until 1921, at the end of the ten-year intervention by Fabrizio Lucarini, who completely repainted the color of the green clothing of the third left angel. In spite of this intervention, the lifting and losses in the painted surface continued, which led to the final and most complete restoration which seems to have definitively eliminated the shifting of the support.

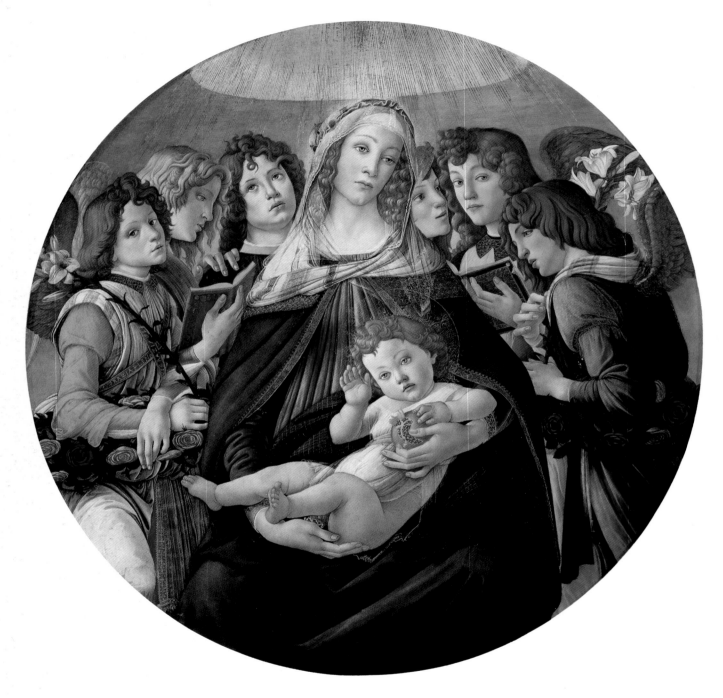

65. Madonna of the Pomegranate
diam. 143.5 cm
Florence, Uffizi

66. Madonna of the Magnificat
diam. 115 cm
Florence, Uffizi

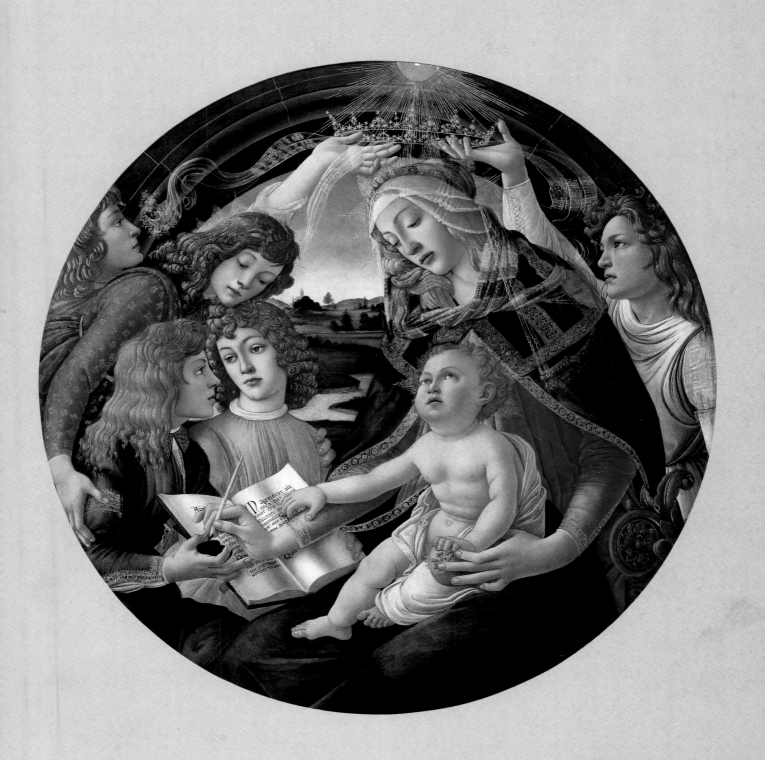

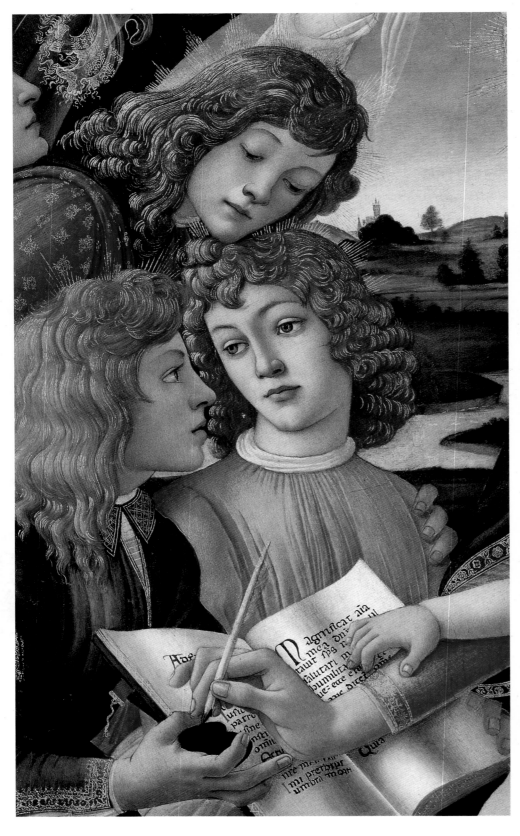

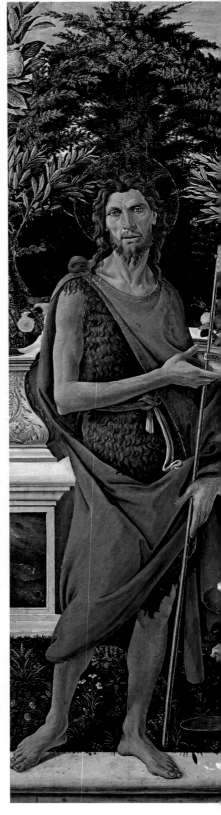

The charm of the painting resides essentially in the complex component organization of the heavenly vision, laden with elements drawn from the doctrinal and symbolic solicitations favoured by the apocalyptical meditations consequent upon Savonarola's presence in Florence, which shortly after would provoke the political and institutional upheavals that followed the first expulsion of the Medici from the city in 1494.

And in fact, the figure of the saint of visions and revelations contained in the last book of the Scriptures, John the Evangelist, is the medium, through

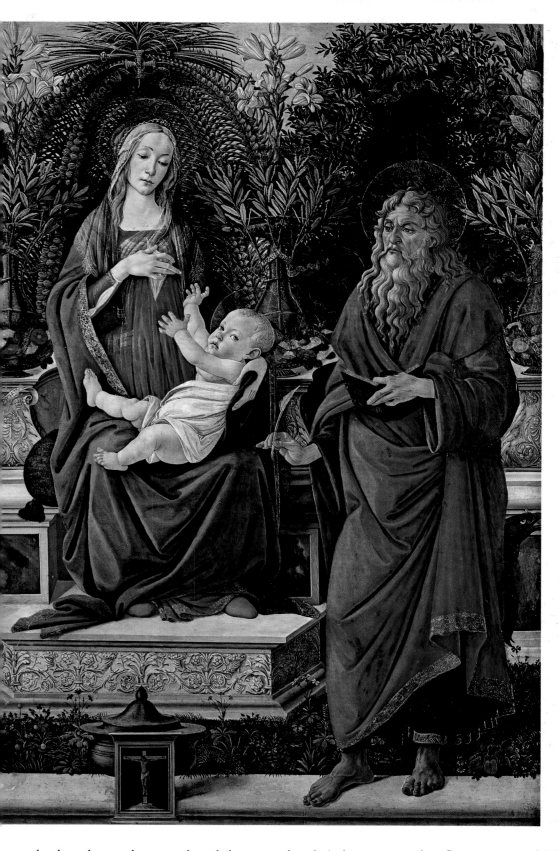

67. *Madonna of the Magnificat, detail Florence, Uffizi*

68. *Madonna Enthroned with St John the Baptist and St John the Evangelist (Bardi Madonna)*
185 x 180 cm
Berlin, Gemäldegalerie Dahlem

the hand raised upward and the open book (white, because he still awaits the words which issue from the heavenly images), between the motionless figures of the onlookers (Augustine, Jerome and Eligius) and the fantastic caroussel of angels around the arc of cherubim and seraphim enclos-

ing the Coronation of Mary. Amidst the dazzle of the gloria, the shower of roses, the apparition of the background angel between the screens of golden rays, the setting of the earthly landscape, bristling with desolate rocks and meadow on which the figures stand, the painting seems to affirm the

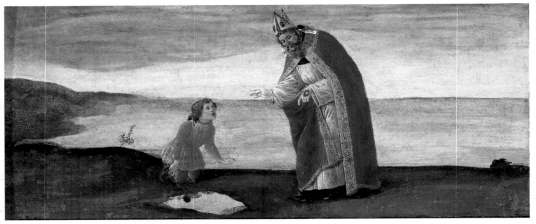

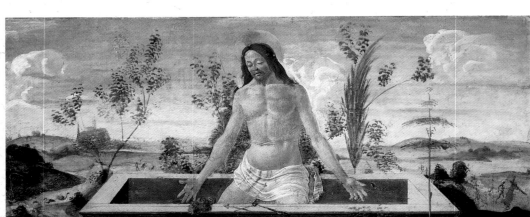

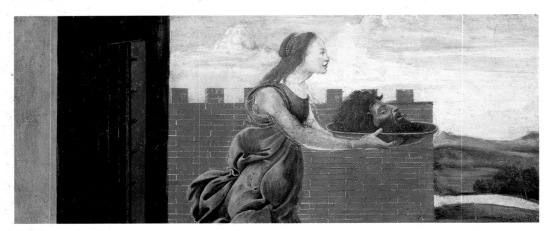

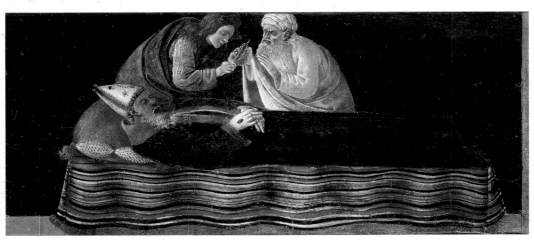

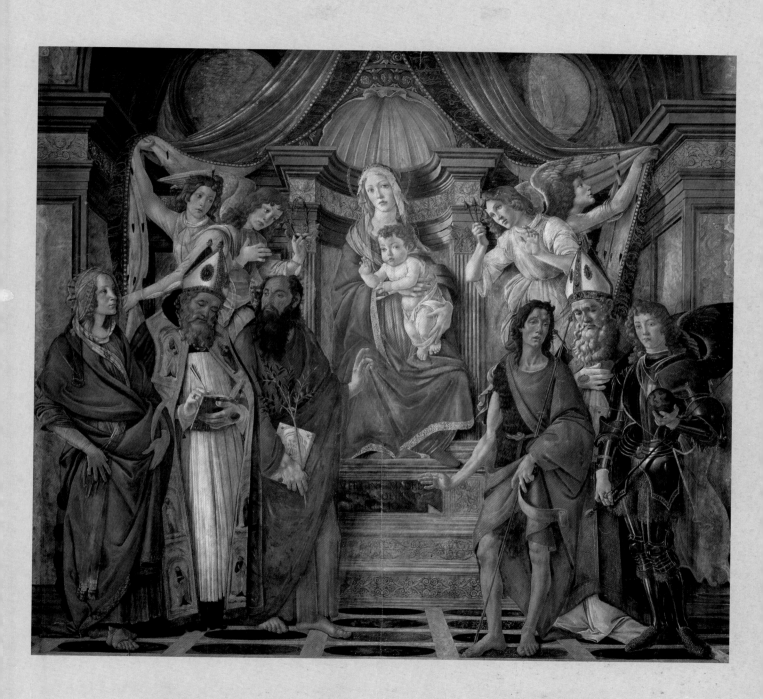

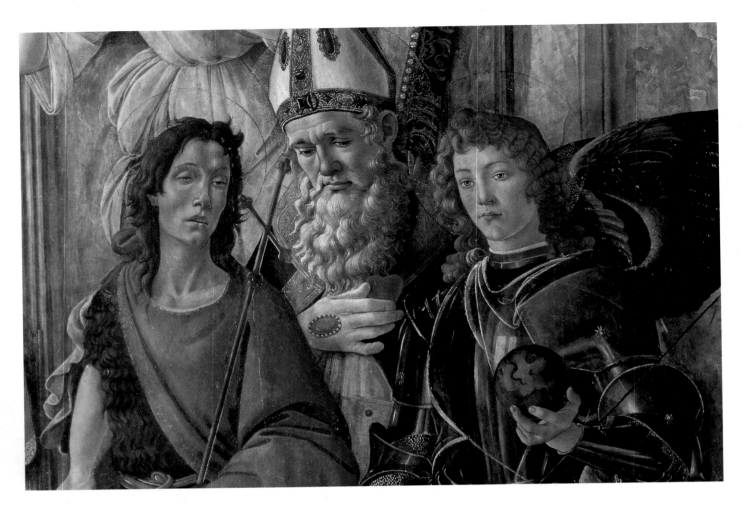

74. *San Barnaba Altarpiece, detail*
Florence, Uffizi

75. *Coronation of the Virgin (San Marco Altarpiece)*
378 x 258 cm
Florence, Uffizi

dialectic between the alluring phantasmagoria of heavenly reality and the scabrousness of worldly existence.

It is therefore evident in this painting that as a result of the splendid restoration the transcendence of that realistic and rational 15th-century figurative organization, towards ulterior compositional goals, is made to quiver with manifest clarity, making this painting one of the most important among those which mark the beginning of the artist's final period of activity.

The large *Annunciation* now in the Uffizi was commissioned in May 1489 by Benedetto Guardi for the convent of Cestello, which was then in Borgo Pinti, more or less where the Church of Santa Maria Maddalena dei Pazzi is now. This painting was rediscovered in 1870 in a villa in Fiesole which belonged to a group of nuns of that order. A recent restoration (1986), parallel with that of the *Birth of Venus*, has taken care of the damage wrought by a 19th-century intervention, which had partly abrased the original egg-white varnish, scratched the azurite of the sky in the background and worn down the gold of the elegant contemporary frame, decorated in the upper frieze with palmette motifs and angelical protoma, in the side pilaster strips with candelabra and — at the base of these — with

the coats-of-arms of the person who commissioned it. The predella — accompanied by lapidary inscriptions drawn from the Scriptures and the Magnificat — contains in the middle a touching image of Christ in pietà, from whose open sarcophagus, as a further theme of painful meditation, hangs the cloth of Veronica. The conservative intervention has restored richness and clarity to the composition, which presently reveals all the dramatic poignancy of the mature expression of Botticelli's art.

Scholars have pointed out the 'too elaborate' coloring of this painting, which it seems was the result of the collaboration of Filippino Lippi "whose artistic sensibility does not coincide with Botticelli's emotional research and who looks for expression in unnecessary luxury" (Bettini). But the conception of the two figures, with the angel almost bent

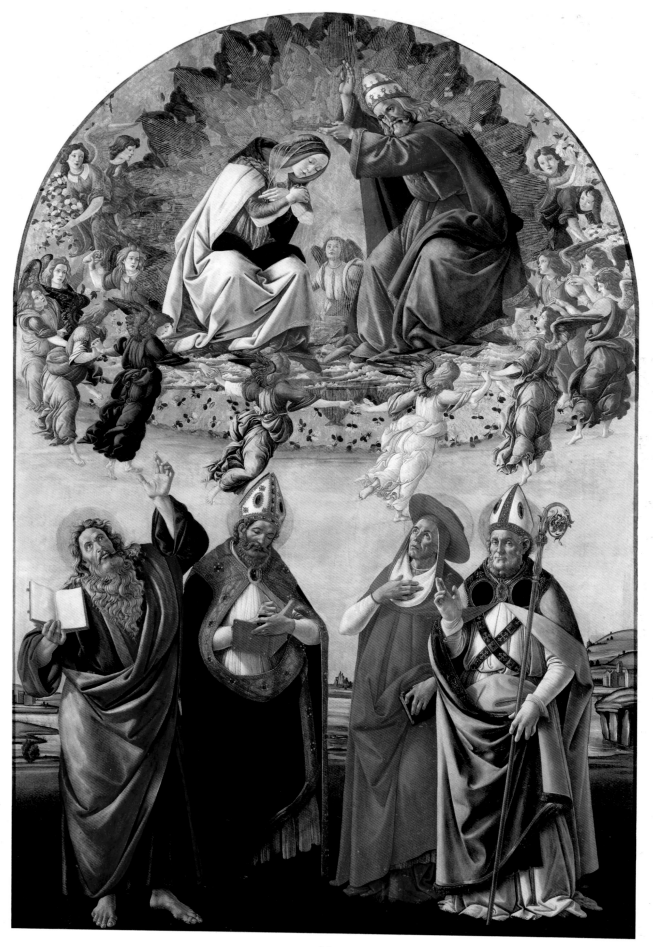

61

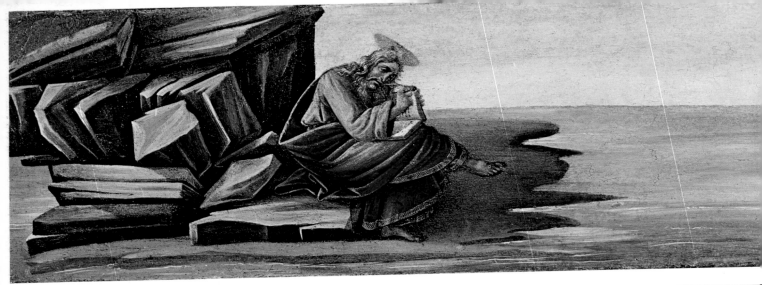

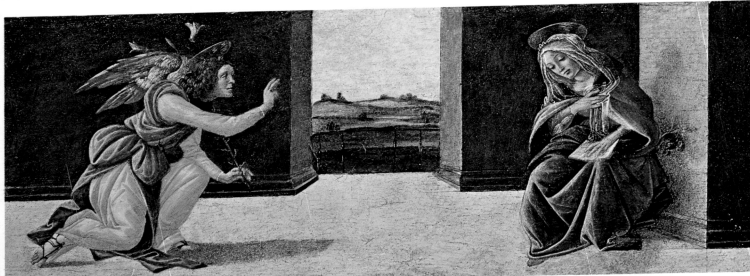

to the ground and the Virgin's reticent and contorted position, show how far Botticelli had come in his personal search for an artistic expression that would coincide with his spiritual tension. And, in fact, his purely Renaissance style is here enriched with forms that remind us of an archaic, almost Gothic kind of painting (the unreal folds in the angel's clothing and the Virgin's body almost twisted into a spiral). But at the same time the extremely modern elements of Botticelli's painting, already present in the *San Barnaba Altarpiece*, reappear in the architecture. Notice in particular the door which opens onto the background landscape.

This monumentality of architecture can be found again in the little *St Augustine in his Study* in the Uffizi, to be dated around 1490-1500 and mentioned in the records of the Vecchietti family, one of the most important Florentine families. The element of movement, which Botticelli never forgot in any painting, is given here by the opening curtain which reveals the saint and which hangs from a metal rung that coincides with the base of the arch

76-80. Predella of the San Marco Altarpiece
21 x 268 cm
Florence, Uffizi

St John on the Island of Patmos

Annunciation

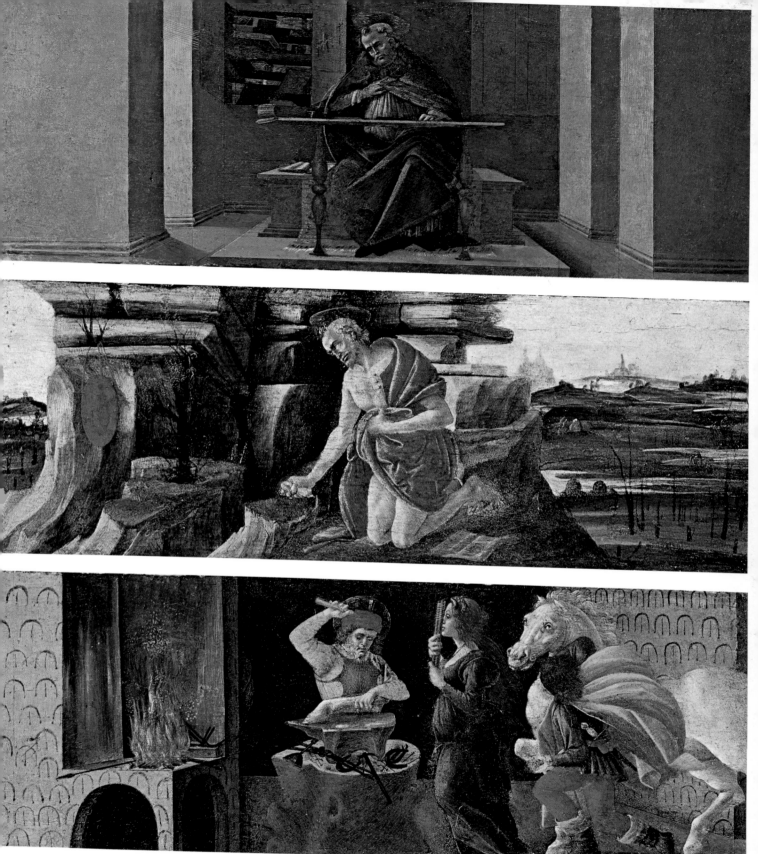

t Augustine in his Study

t Jerome in the Wilderness

A Miracle of St Eligius

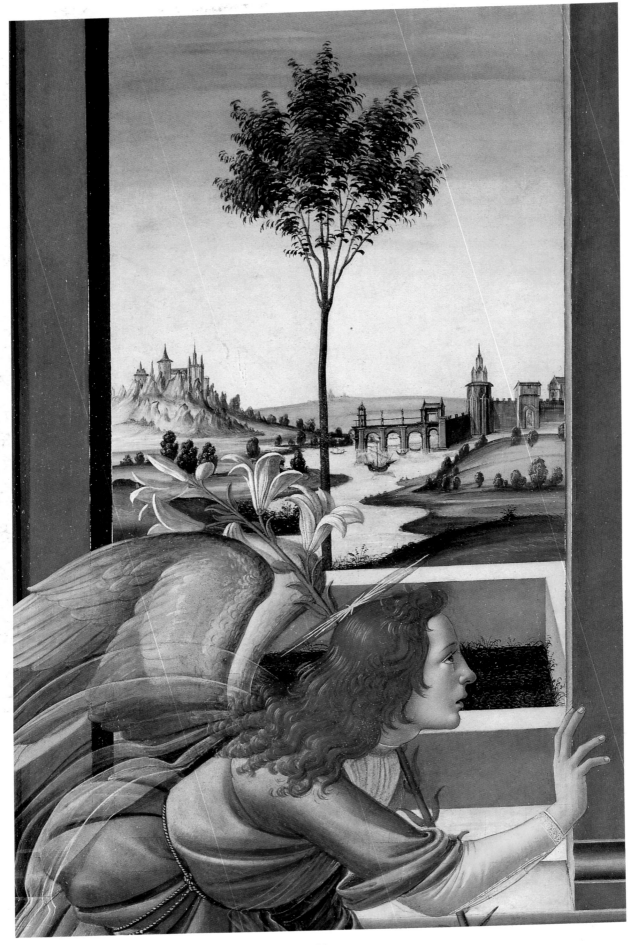

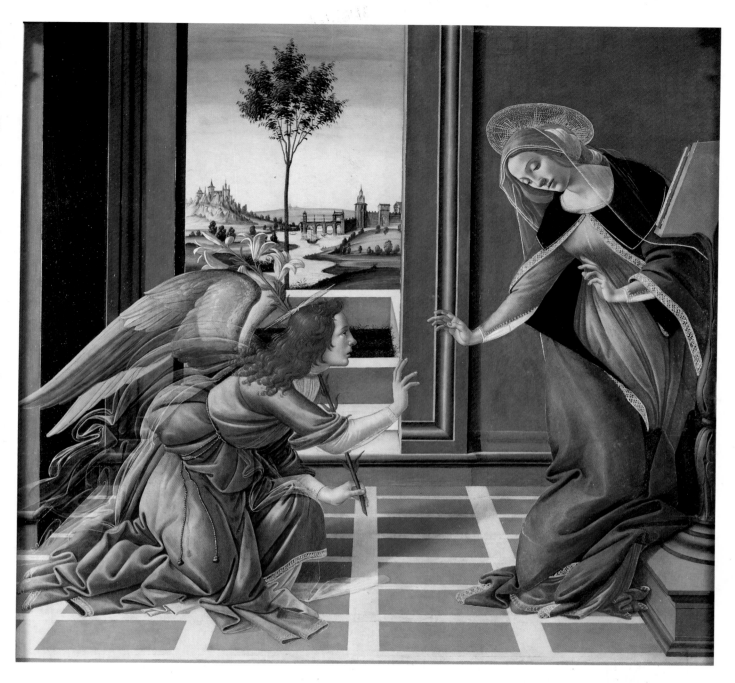

81, 82. Annunciation
150 x 156 cm
Florence, Uffizi

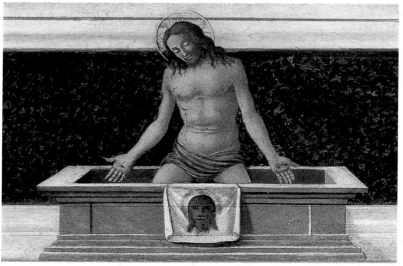

83. Annunciation
detail of the predella
with Christ in the
Sepulchre

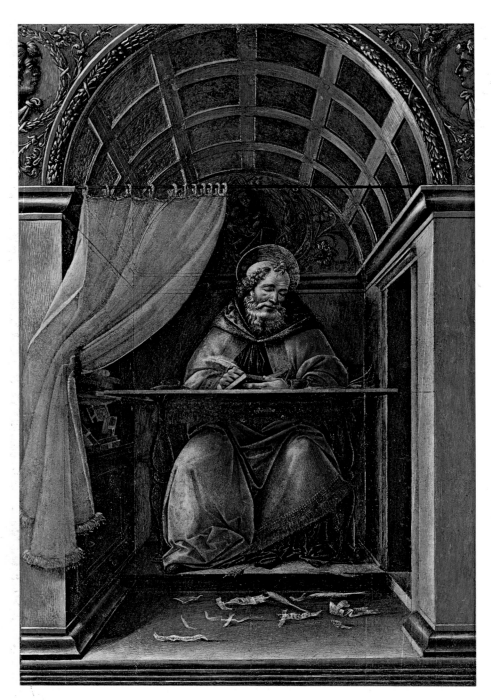

above St Augustine's chair. The synthesis of Humanism and Christianity — that is, the two poles of Botticelli's cultural and artistic development — is symbolized in the medallions with classical profiles above the columns and in the lunette at the back with the Madonna and Child. Another detail of Botticelli's expressionism is given by the bits of paper strewn carelessly on the floor.

The *Communion of St Jerome* in the Metropolitan Museum in New York was also painted around this time. The symbolism and the hyperbolic proportions, so common in Botticelli's later work, are present here. See, for example, the crucifix with palm fronds which seems to refer to St Jer-

ome's imminent death, while he receives communion in his hermitage. Even the figures of the acolytes, unrealistically bent in the hermit's hut, are by this time quite common features of Botticelli's painting and they reveal his interest in figurative research, very different from the naturalistic and narrative trends of the late fifteenth century in Florence (consider the work of his pupil Filippino and of Domenico Ghirlandaio).

This innovation, both in subject-matter and in representation, is carried further in the famous painting of *Calumny*, which reproduces the subject of a painting by the Greek painter Apelles, described in classical times by Lucian and men-

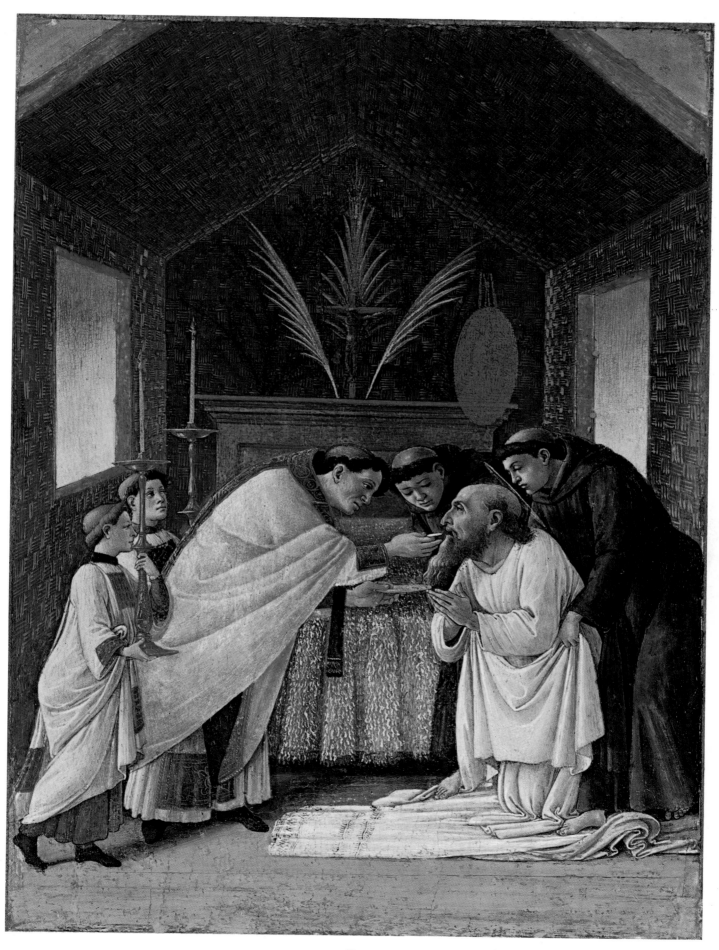

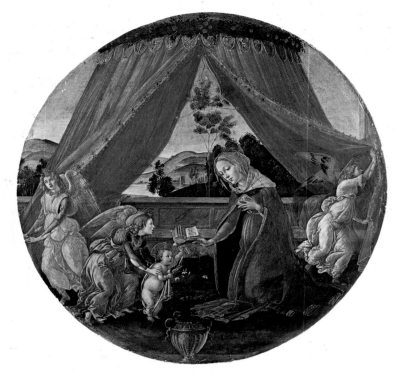

86. *Madonna Adoring the Child with Angels ('Madonna del Padiglione')*
diam. 65 cm
Milan, Pinacoteca Ambrosiana

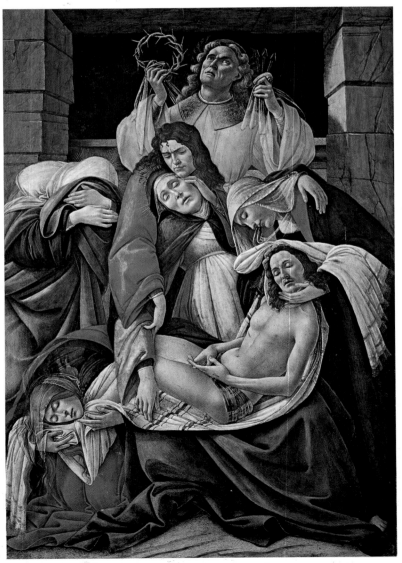

87. *Lamentation Over the Dead Christ*
107 x 71 cm
Milan, Museo Poldi Pezzoli

88. *Mystic Nativity*
108.5 x 75 cm
London, National Gallery

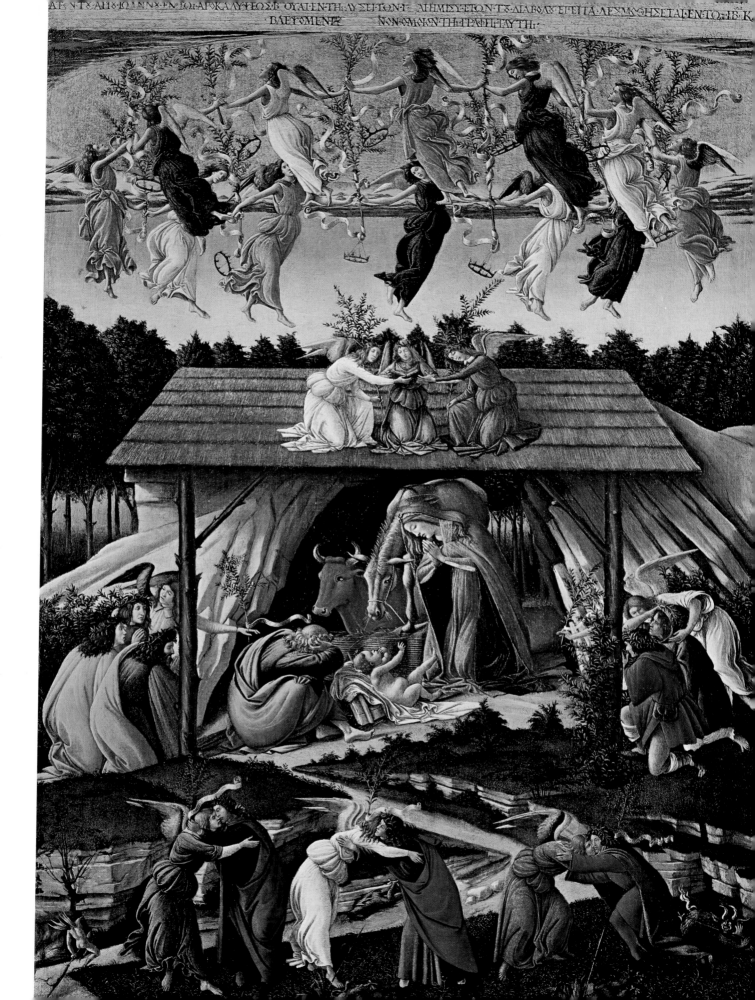

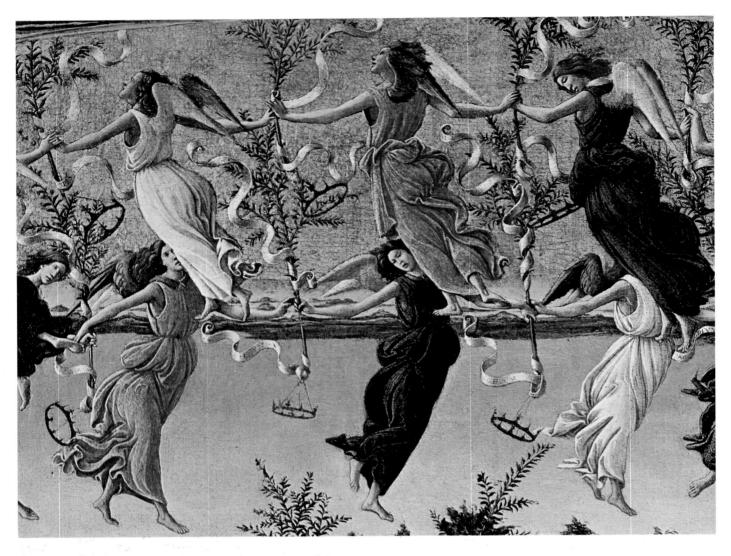

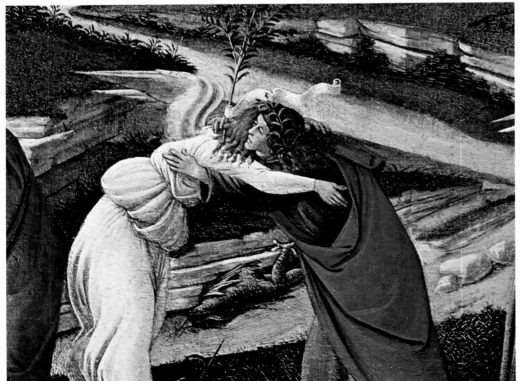

*89, 90. Mystic Nativity,
details
London, National Gallery*

*91. Calumny
detail of Truth and
Remorse
Florence, Uffizi*

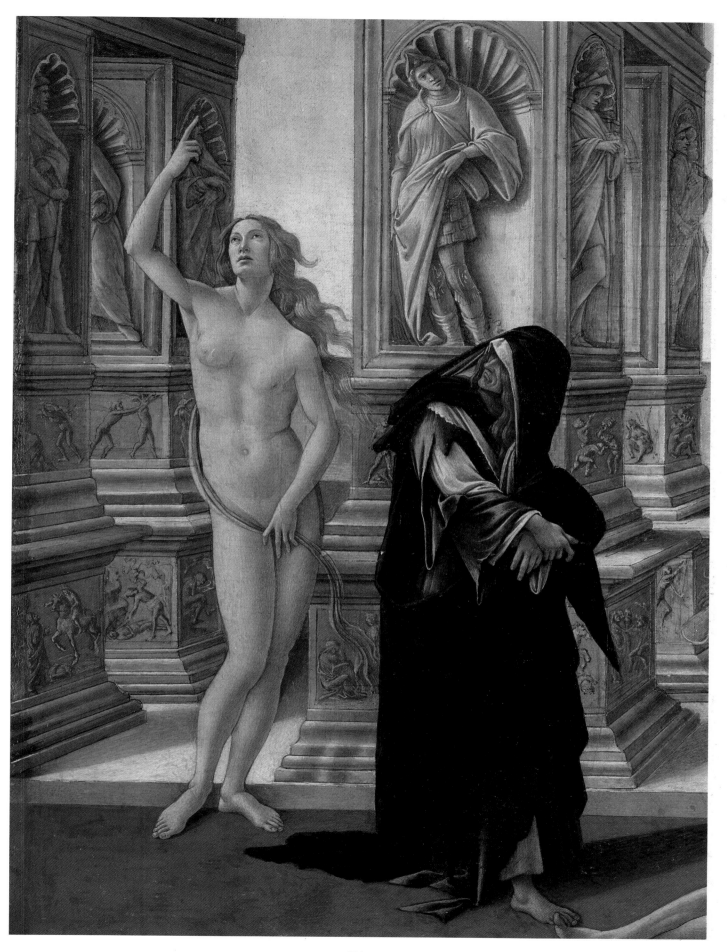

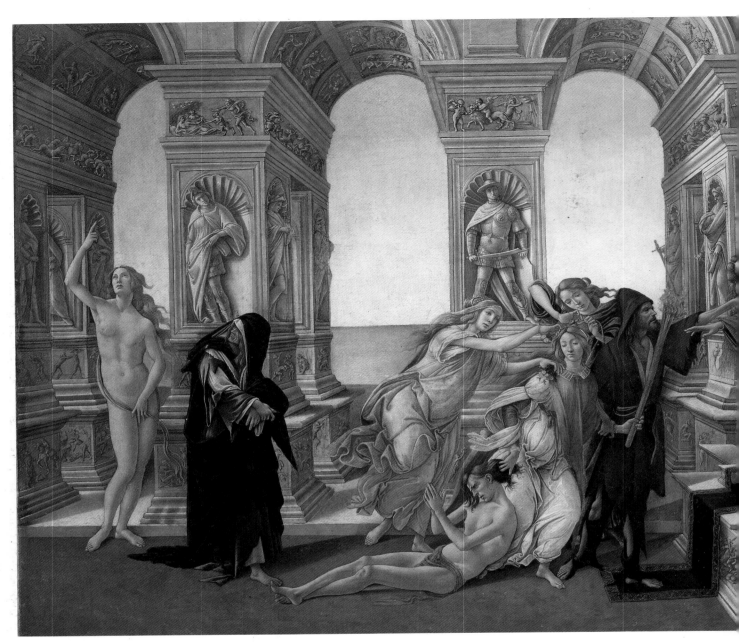

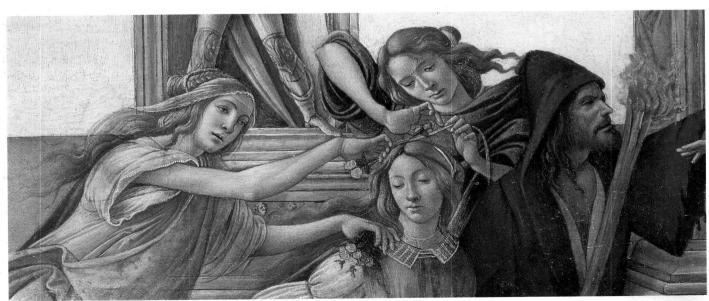

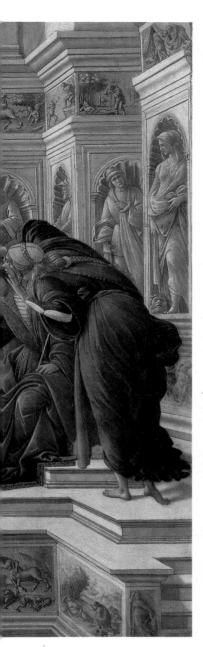

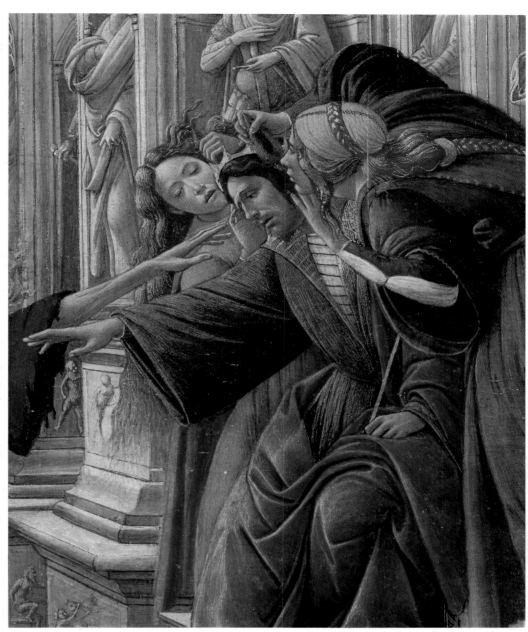

92. *Calumny*
62 x 91 cm
Florence, Uffizi

93. *Calumny*
detail of Malice, Calumny, Envy and Fraud

94. *Calumny*
detail of King Midas between Ignorance and Suspicion

tioned in the Renaissance by Leon Battista Alberti in his treatise *De Pictura*. In this painting there is a representation of King Midas, with ass's ears, listening to the false words of Ignorance and Suspicion. In front of them, standing, is Malice who precedes Calumny. Calumny is accompanied by Envy and Fraud, dragging Innocence by the hair. Behind this group is the hooded figure of Remorse, who turns to look at the naked figure of Truth. This is the allegory of the painting which is set in a large hall with archways that are fully sixteenth-century in style. Through these we can see a clear faraway landscape of sky and completely barren countryside and along the walls of the room are niches with figures from classical antiquity and from the Scriptures. Also of similar subject-matter are the monochrome reliefs that decorate the arches and

the bases of the columns. The blending of classical and biblical elements takes us back to the Humanist meditations on the possibility of reconciling pagan thought and Christian tradition. But the figures, as though tossed about by a strong wind that dies in the face of the monumental image of Truth, reveal how Botticelli's restlessness releases itself in the meditation on the mystery of man face to face with the two greatest spiritual movements of the West, classical culture and Christianity. This painting is essentially conceptual and its figures bear no relationship to reality. *Calumny* is today at the Uffizi and has been dated between 1490 and 1495.

Botticelli's versatility, from this stage onwards, is only expressed in his choice of subjects, which as we have seen cover a wide range: from allegories and religious subjects to the illustration of literary themes. But the guiding principal through all these different subjects is the lyrical mood which is present in all Botticelli's paintings. The Madonna adoring the Child with three angels (*Madonna del Padiglione*) in the Pinacoteca Ambrosiana in Milan was painted in the 1490s. In this work Botticelli successfully blends the traditional aspects of Florentine painting (the solid construction of the elements creating the space: see the curtain held open by two angels) with a delicate landscape, plainly inspired by Leonardo's work. The features of the figures still show a subtle melancholy and each one seems deep in personal meditation. This division of emotions is unified by the religious aspect of Botticelli's own meditation.

Very different because of its bright, almost too brilliant colors, and because of the disproportionate sizes of the figures, half way between prostration and hope, is the painting called the *Mystic Nativity* in the National Gallery in London. Evil is conquered by brotherhood and by prayer; these are the thoughts of the elderly painter. This is his only dated work (the year 1501 is legible in the inscription in Greek at the top) and it contains, also in the inscription, a reference to the historical conditions of his country at the time — "during the dark moments of Italy". It is also his first work to refer to, even though only indirectly in the inscription, Savonarola (at least this is the opinion of many scholars). In this painting too, the presence of archaic elements, such as the olive branches tied to the scrolls or the reduced size of some of the figures, contrasts strongly with the wide-open space, with the poses of the characters and with the intensity of emotion which pervades the entire work. We may say that the painting is visionary in its conception and conservative in its figurative elements. The expressionism of Botticelli's later works derives also from this very contrast, which singles

him out as an isolated figure in the artistic context of Florence at the beginning of the sixteenth century, characterized by the young Michelangelo and by the sharp division of artists into Classical or Mannerist.

Even more impressive, and, for this reason, appropriate as a conclusion to this partial analysis of Botticelli's painting, is the *Mystic Crucifixion* in the Fogg Art Museum in Cambridge, Massachusetts. The Christ figure on the cross dominates from above a city that looks very much like Florence. On the left is God the Father despatching groups of angels with shields with crosses on them, while on the right, in a black cloud, some devils are throwing burning torches. In the lower part is Mary Magdalen, desperately clutching the foot of the cross. Opposite her is an angel striking an animal that looks like a lion (perhaps it is a reference to the Marzocco lion, the emblem of Florence), while a second animal escapes from Mary Magdalen's gown. Here again the interpretations of scholars on the meaning of this allegory are manifold, but it seems certain that it was inspired by one of Savonarola's sermons. We could summarize the most likely interpretation by saying that Mary Magdalen represents the repenting city of Florence, which is protected against evil by divine intervention. The historical reference of all this is almost certainly the fact that, in 1502, Cesare Borgia called off his invasion of the territory of the Republic at the last minute and the city was spared. Thus, once again we see the political commitment of Botticelli, taking part as he did in the life of his city with his art and still capable of producing works of remarkable power. We must add here that the influence of Savonarola on Botticelli, so often denied by the scholars, is evident above all in the last years of his life in his choice of religious subjects which contain apocalyptic and prophetic elements and are, therefore, more easily expressed through allegories which are characteristic of the writings, the sermons, and the religious, civil and political activity of the Dominican from Ferrara.

Botticelli's dilemma, which although of an essentially personal nature must have influenced his artistic production and his pictorial style, is based on the contrast between two different worlds: the Humanist world with its chivalric and almost pagan content, experienced in the Medici circle, and the

95. Mystic Crucifixion
73 x 51 cm
Cambridge (Massachusetts), Fogg Art Museum

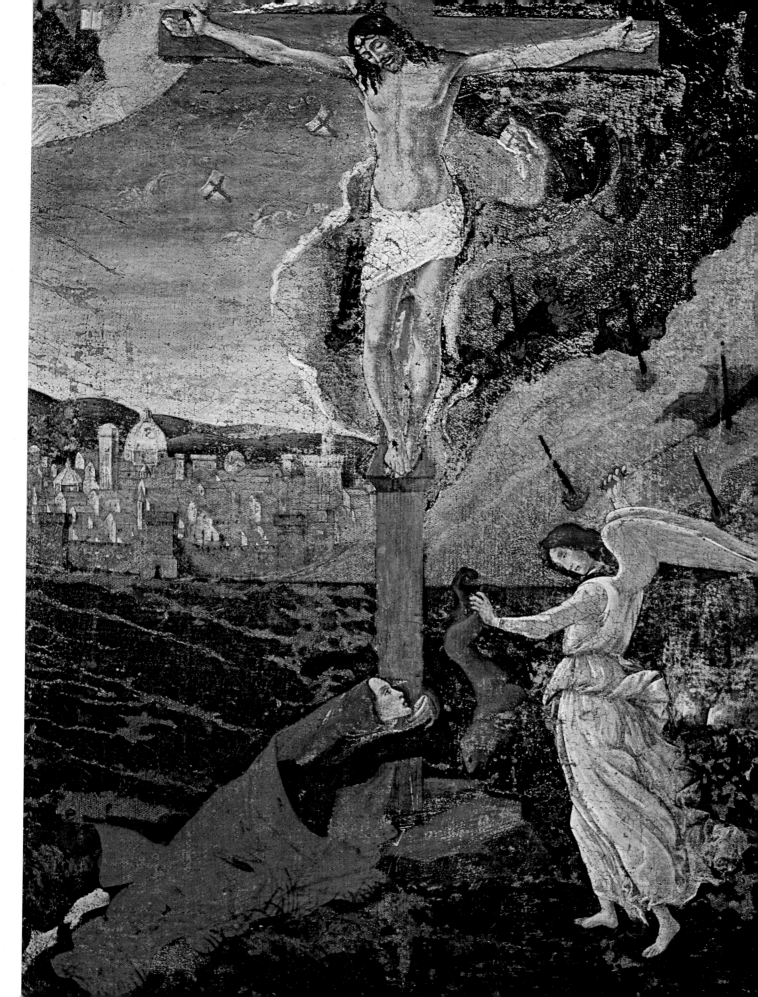

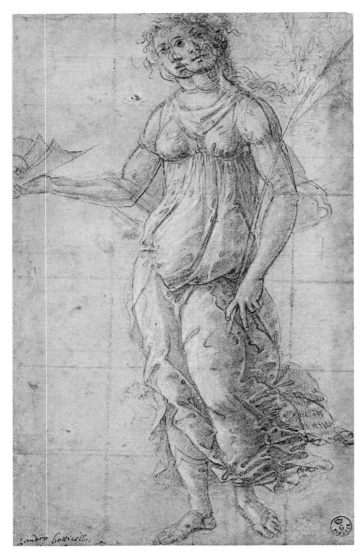

reforming and ascetic rigor of Savonarola, who used Christianity not only as a personal ethic, but also as a guide to a coherent civic and political commitment, contrasting 'Christ King of Florence' (which his followers wanted to carve over the door of Palazzo Vecchio) with the splendid but tyrannical and corrupt power of the Medici.

Botticelli lived intensely and coherently in both these cultural environments and from them he drew the inspiration for his art. His harshness, his imagination and the quality of his painting unite his works, regardless of which of the two cultural worlds inspired them. Even when he seems backward and closed in on himself — as in his last works — we cannot neglect his greatness, the greatness of a man who lived for sixty-five years and worked for the best part of half a century.

To conclude we shall discuss briefly Sandro's achievements in the field of drawing and the applied arts. We have already mentioned his interest in Dante and there are sources which state that he illustrated the *Divine Comedy* for Lorenzo di Pier-

96. Pallas
Florence, Uffizi, Collection of Prints and Drawings

97. Angel
Florence, Uffizi, Collection of Prints and Drawings

98. Birth of Christ
Florence, Uffizi, Collection of Prints and Drawings

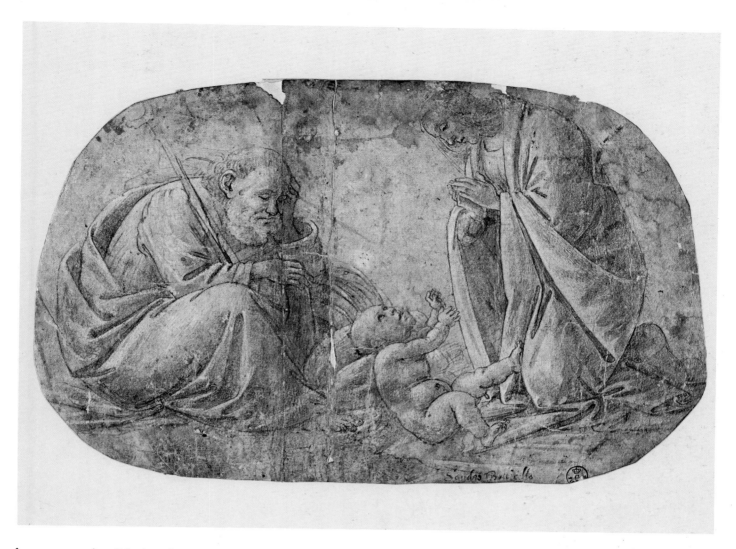

francesco dei Medici between 1490 and 1496. These drawings are now dispersed, some in the Vatican Museums and some in the museums of Berlin. These drawings are comparable stylistically to his later works, because they are full of archaic elements and the figures in them have nothing at all realistic about them.

The doors of the Sala dei Gigli in Palazzo Vecchio seem to have been carved on Botticelli's design by Francione, a well-known Florentine carpenter, and by the sculptor and architect Giuliano da Maiano, probably at the time when these two artists were working in the building (1478). The two inlaid figures, which look very static, are *Dante* and *Petrarch*. Botticelli also designed the wood paneling for the study of Federigo da Montefeltro, the Duke of Urbino. This work dates from 1476 and consists of allegorical figures, typically Botticellian in their movements and poses, alternated with representations of objects. Botticelli was a true master of drawing, almost the emblem of fifteenth-century painting in Florence; his name stands out in the most fruitful and successful period of Florentine art, the late Quattrocento. It is difficult to separate his personality from the environment of his principal patrons, the Medici; this environment is usually considered serene, carefree (see, for example, Lorenzo the Magnificent's well-known carnival song 'Enjoy today; Nought ye know about tomorrow'), lucidly sceptical, culturally prolific, and economically rich. But in reality Botticelli's art reflects all the restlessness and worry of the society of his time and of the city he lived in. Perhaps the most 'Florentine' of all painters, Sandro Botticelli portrayed better than any other artist all the tension of an age of great cultural and political creativity, but also an age that witnessed overwhelming social and historical upheavals.

99, 100. Illustrations for the
Divine Comedy
Vatican, Vatican Library

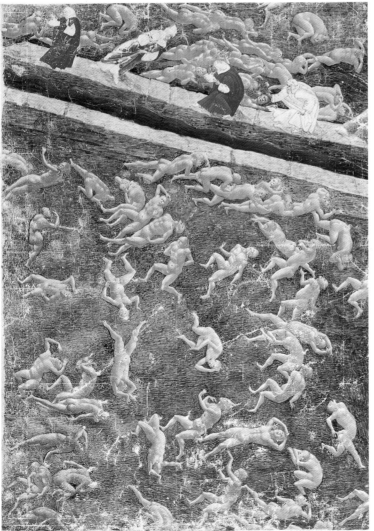

Index of the Illustrations

Adoration of the Magi (Florence, Uffizi), 1, 15-19

Adoration of the Magi (Washington, National Gallery), 62, 63

Angel (Florence, Collection of Prints and Drawing), 97

Annunciation (Florence, Uffizi), 43

Annunciation (Florence, Uffizi), 81-83

Bardi Madonna (Berlin, Gemäldegalerie Dahlem), 68

Birth of Christ (Florence, Church of Santa Maria Novella), 20

Birth of Christ (Florence, Collection of Prints and Drawings), 98

Birth of Venus (Florence, Uffizi), 32-38

Calumny (Florence, Uffizi), 91-94

Communion of St Jerome (New York, Metropolitan Museum), 85

Coronation of the Virgin (San Marco Altarpiece) and predella (Florence, Uffizi), 75-80

Destruction of the Children of Korah (Vatican, Sistine Chapel), 53-56

Discovery of the Body of Holofernes (Florence, Uffizi), 10

Fortitude (Florence, Uffizi), 8

Illustrations for the Divine Comedy (Vatican, Vatican Library), 99, 100

Judith's Return to Bethulia (Florence, Uffizi), 11

Lamentation Over the Dead Christ (Milan, Museo Poldi Pezzoli), 87

Madonna and Child with an Angel (Boston, Isabella Stewart Gardner Museum), 12

Madonna of the Pomegranate (Florence, Uffizi), 65

Madonna of the Book (Milan, Museo Poldi Pezzoli), 64

Madonna of the Magnificat (Florence, Uffizi), 66, 67

'Madonna del Padiglione' (Milan, Pinacoteca Ambrosiana), 86

Madonna of the Rosegarden (Florence, Uffizi), 4

Madonna in Glory with Seraphim (Florence, Uffizi), 2

Mystic Crucifixion (Cambridge/Mass., Fogg Art Museum), 95

Mystic Nativity (London, National Gallery), 88-90

Nastagio degli Onesti (Madrid, Prado), 39-41

Pallas (Florence, Collection of Prints and Drawings), 96

Pallas and the Centaur (Florence, Uffizi), 61

Portrait of Giuliano de' Medici (Bergamo, Accademia Carrara), 21

Portrait of a Man with the Medal of Cosimo the Elder (Florence, Uffizi), 13

Portrait of a Young Man (Florence, Galleria Palatina), 9

Portrait of a Young Man (London, National Gallery), 60

Portrait of a Young Woman, called "Simonetta" (Florence, Galleria Palatina), 22

Primavera (Florence, Uffizi), 23-31

San Barnaba Altarpiece and predella (Florence, Uffizi), 69-74

Scenes from the Life of Moses (Vatican, Sistine Chapel), 44-47

St Augustine (Florence, Church of Ognissanti), 42

St Augustine in his Study (Florence, Uffizi), 84

Temptation of Christ (Vatican, Sistine Chapel), 48-52

Venus and Mars (London, National Gallery), 57-59

Other Artists

Filippo Lippi: Madonna and Child with Angels, 3

Antonio Pollaiolo: Hercules and Antaeus, 6

Piero Pollaiolo: Temperance, 5

Andrea Verrocchio: Doubting Thomas, 7

Short Bibliography

F. ALBERTINI, *Memoriale di molte statue e pitture che sono nell'inclyta ciptà di Florentia*, Florence, 1510

Il libro di Antonio Billi (1481-1530), ed. by A. Frey, Berlin, 1892

Il Codice Magliabechiano (1537-1542), ed. by A. Frey, Berlin, 1892

G. VASARI, *Le vite dei più eccellenti pittori, scultori e architettori* (ed. 1568), with new annotations and comments by G. Milanesi, Florence, 1878-1881

H. ULLMANN, *Sandro Botticelli*, Munich, 1893

I. B. SUPINO, *Botticelli*, Florence, 1900

H. HORNE, *Alessandro Filipepi commonly called Sandro Botticelli*, London, 1908

W. BODE, *Botticelli*, Berlin, 1921

A. SCHMARSOW, *Sandro del Botticello*, Dresden, 1923

Y. YASHIRO, *Sandro Botticelli*, London-Boston, 1925

A. VENTURI, *Botticelli*, Rom, 1925

G. GAMBA, *Botticelli*, Milan, 1936

S. BETTINI, *Botticelli*, Bergamo, 1942

R. SALVINI, *Tutta la pittura del Botticelli*, Milan, 1958

G. MANDEL, *L'opera completa del Botticelli*, introduction by Carlo Bo, Milan, 1967

La Nascita di Venere e l'Annunciazione del Botticelli restaurate, Florence, 1987

L'Incoronazione della Vergine del Botticelli: restauro e ricerche, Florence, 1990

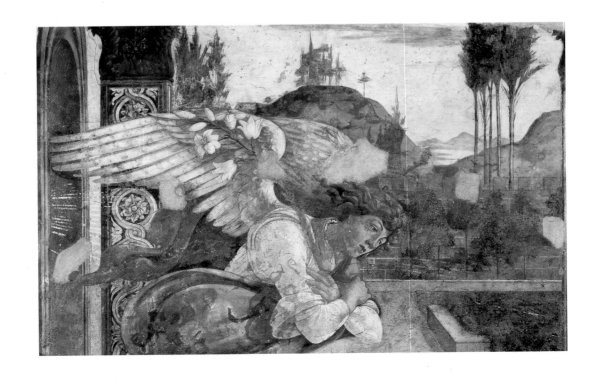